IMAGES
of America

VANISHING
VANCOUVER

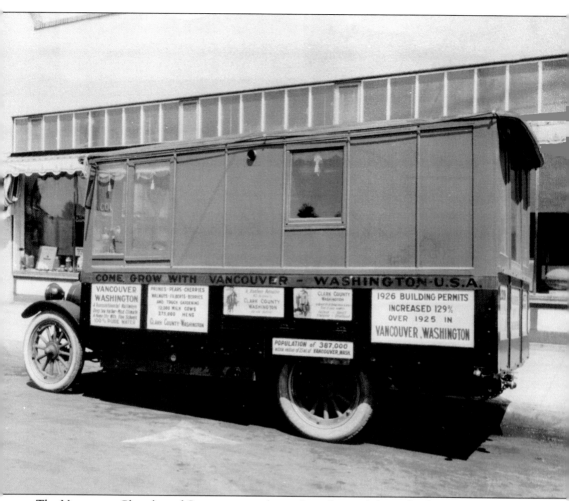

The Vancouver Chamber of Commerce truck stands in front of the *Columbian* office, ready to spread the news about Vancouver, Washington. It is 1926, and Governor Liston has changed the spelling of Clarke County to Clark County. It is a year after the centennial celebration. The prune industry is waning, with competition from canned fruit and California sun-dried prunes having joined with the loss of sales to the distilleries. Prohibition is still in effect, which has closed down the brewery, one of the city's main industries. (Greater Vancouver Chamber of Commerce.)

ON THE COVER: By the 1920s, Vancouver had a definitive urban feel. The view in this image, taken from the First National Bank, now the Heritage Building at Sixth and Main Streets, looks toward the Interstate Bridge. No horses or wagons are visible on the roadways, but two streetcars make their way from Second Street. On the east side of the street are the Oyster Loaf Restaurant, the Log Cabin Saloon, and the Shipyard Club. The Columbia Hotel, with its distinctive pyramid tower, stands at Second and Main Streets, while the large dark building to the right of the bridge is the city prune warehouse. All of these are now gone. (Courtesy of the author.)

IMAGES
of America

VANISHING
VANCOUVER

Pat Jollota

ARCADIA
PUBLISHING

Published by Arcadia Publishing
Charleston, South Carolina

Printed in the United States of America

Library of Congress Control Number: 2013932178

For all general information, please contact Arcadia Publishing:
Telephone 843-853-2070
Fax 843-853-0044
E-mail sales@arcadiapublishing.com
For customer service and orders:
Toll-Free 1-888-313-2665

Visit us on the Internet at www.arcadiapublishing.com

In 1982, I arrived in Vancouver a complete stranger. My husband and I knew no one. How quickly we were welcomed into Vancouver's life! This town has embraced and supported me through sad times and joy. Thank you, Vancouver. This book is offered to the people of this community.

CONTENTS

ACKNOWLEDGMENTS

Linda Lutes, photograph archivist at the *Columbian* newspaper, is a treasure. A gifted photographer herself, she appreciates the window into the past that these images give us. Michael Jaffe, of Boardman Stamps, is truly a Renaissance man with a myriad of interests. He is open and generous with his amazing collection of images. Jennifer Peterson shared her family's history as well as great tea. Greg Shine, chief ranger at the Fort Vancouver National Historic Site, shares wonderful discoveries with joy. He is there to answer questions and confirm dates. Matt Oftedahl, records supervisor at the Port of Vancouver, is the expert at placing just where and when in the port a photograph was taken. Thanks are also offered to Kelly Parker, of the Greater Vancouver Chamber of Commerce; Brian Loos of Clark County Public Works; Brian Carlson; the City of Vancouver; Julie Crockett of Smith-Reynolds Post No. 14; and, of course, Bill Alley, the expert on Pearson Field who kept me straight on dates and types of aircraft. Henry Spang and the pilots at Pearson shared stories. Julie Crockett of the American Legion was a great help. Of course, the list would be incomplete without mention of my patient acquisitions editor, Rebecca Coffey at Arcadia Publishing, who always had time for my questions. Unless otherwise credited, these images are from my own collection.

INTRODUCTION

Vancouver City, Columbia City, La Jolie Prairie, the First Vancouver, America's Vancouver, Vancouver USA, "The 'Couve"—this city on the north bank of the Columbia river has been known by many names. The name changes reflect the dynamic changes in the city itself.

As an outpost of the Hudson's Bay Company, it was referred to as the "New York of the wilderness," a place of trade, culture, and European civilization. Then, as now, tastes changed, such as beaver felt hats declining in favor. The company diversified and changed.

Brewing since the Revolution, squabbles between Britain and the United States over ownership of the land began and escalated. Slogans such as "Fifty-four Forty or Fight!" and "All of Texas, all of Oregon, or war!" exacerbated the tensions. At last, those issues were settled by the Treaty of 1846. As the premier British presence in the Northwest, the Hudson's Bay outpost was a pawn in those deliberations. After the treaty, it found itself deep in United States territory.

Henry Williamson, one of the few Americans that Dr. John McLoughlin and the Hudson's Bay Company allowed to settle near the fort, staked a claim and laid out a tiny town on the bank of the Columbia River. It was just a few blocks square, beginning at a balm of Gilead tree, called the Witness Tree. Williamson named this small town Vancouver City to set it apart from the fort and the village. Today, that little town is completely covered over by restaurants, a trail, and parking lots on the riverfront.

In 1849, three years after the Treaty of 1846, the US Army arrived to set up its camps near the Hudson's Bay fort. The treaty of 1846 directed the United States to reimburse the Hudson's Bay Company for property assumed by the Army. Col. Benjamin Bonneville surveyed the military reservation, beginning at the same Witness Tree that had been used by Henry Williamson. However, Bonneville then proceeded to go 15 degrees off true north so as to include more Hudson's Bay property within the reservation. Maps of today show the 10,420-acre site of the reservation lying athwart the map. The I-5 Freeway follows the west boundary at 15 degrees from true north, with dozens of irregularly shaped parcels along the edges.

Amos and Esther Short successfully usurped Henry Williamson's land claim. Amos shot and killed a Hudson's Bay agent and a Hawaiian worker during his dispute over title to the claim. After his trial, and exoneration, he became a probate judge. He traced over Williamson's map of Vancouver City and renamed it Columbia City, to reflect its American status. The name did not last. A few short years later, the legislature changed the name to Vancouver, dropping the word *city*.

Amos Short drowned when the ship *Vandalia* went down while entering the Columbia River. After his death, Esther Short came into her own. When she discovered that Amos had never recorded their claim, titles to all of her holdings were hopelessly clouded. She chose to ignore those clouds. She allowed a ferryboat to dock on the corner of her land claim, at what would be the foot of Washington Street if that street still reached the river. Business and traffic grew at that point. Because of the road development, it was the logical place for the Interstate Bridge. The only

suitable route for the Pacific Highway was at the connection to the bridge. When congestion on the highway led to the search for a site for another span, the only location that eased congestion was parallel to the first. The second span and the freeway consumed more of downtown.

Esther Short, in her will, left the waterfront portion of her claim to the City of Vancouver to be a public wharf. The Port of Vancouver grew. A port district was formed in 1912, and the busy and profitable port expanded. She left a portion of her claim to the city for a public plaza that is now Esther Short Park. She then excluded all but one of her children from her will. The ensuing legal battles would slow development of the town for decades.

The city expanded or shrank with the fortunes of war. The Civil War called the regular Army. The Spanish-American War sent troops under the command of Gen. Thomas M. Anderson to the Philippines. World War I brought a huge boom to the city with the establishment of the Spruce Production Division, with tens of thousands of men harvesting spruce wood for airplanes. That conflict saw shipyards grow on the riverfront. The biggest of these was the Standifer Shipyards, which lay west of the Interstate Bridge. The collapse of the shipbuilding industry after the first war left abandoned shipways and buildings. The Port of Vancouver was able to acquire that property and expand its operations.

The biggest changes to the cityscape of Vancouver came with the onset of World War II and its aftermath. Kaiser Shipyards sprang up along the shoreline where the Hidden Farm had stood. Thousands upon thousands of new residents poured into the city. New homes, schools, shops, and community centers had to be built for them. The city sprawled to the east. After the war, the housing developments were sold or demolished and redeveloped.

Vancouver has had a history of division. In the early years, the military reservation was a formidable barrier between east and west. The sole road across the reservation was Fifth Street. Mill Plain Road and McLoughlin Boulevard would not be built for decades. Grant Avenue and Evergreen Boulevard (now Officer's Row) would not be opened until the 1960s. Fourth Plain Road would not connect with Twenty-sixth Street until the freeway was built.

The Eisenhower years brought the freeway. Blocks of the downtown disappeared under the cloverleaf to the Lewis and Clark Highway, now Highway 14. Residential streets vanished. Leverich Park was bisected. Yet another dividing line was created between east and west.

Later still, the Columbia River was crossed by the Glenn Jackson Bridge to I-205. With only one on-and-off-ramp within the city, the new highway created another division.

In the last years of the 20th century, catalysts arose that would soon have an impact on our culture. As the 21st century arrived, the changes were gradual but seemingly inexorable. Technology doomed many businesses. Printers, camera shops, bookstores, all purveyors of the goods that could now be produced at home on the computer, were disappearing. Computerized automobiles put many small garages out of business.

Shopping habits changed, customers moved to malls and big-box stores. Smaller retailers could not compete and shuttered their storefronts. Those changes continue and cities continue to change.

The city has grown from a few blocks on the waterfront to a city stretching 15 miles along the Columbia River. From a population of a few hundred, it stands, as of 2012, at over 167,000 souls. If a resident of Vancouver City or Columbia City could travel forward, he or she would be dumbstruck with the changes that have occurred.

The past resident would not recognize anything other than a few spots within the Fort Vancouver National Historic Reserve. He or she most assuredly would not understand the nickname "The 'Couve."

One

THE HUDSON'S
BAY COMPANY

Without the Honourable Company, as the Hudson's Bay Company was called, there would be no city at all. Its decision to site its fort near the junction of the Columbia and Willamette Rivers was the genesis for all that came after.

Settlers were attracted to the security and commerce that Fort Vancouver presented. Employees of the company saw the potential that the countryside offered and chose to stay. As the Oregon Trail opened and immigrants headed west, the fort's stores were open and ready to supply them. As they frequently arrived penniless, Dr. John McLoughlin would often extend credit. This practice did not meet with the company's approval and it demanded the repayment of the loans. That was the cause of McLoughlin's dismissal from the company. The "Father of Oregon" decamped to Oregon City to live out his life.

The company found itself in the center of the ongoing disputes over ownership of the territory, with both the United States and Britain putting forth their claims to the land accompanied by slogans and saber rattling. Just a little more than 20 years after Sir George Simpson broke a bottle of rum on the flagpole and proudly named the fort for the most famous British explorer of the day, the company found itself deep in American country.

The Hudson's Bay Company and the US Army coexisted for another decade as the company removed itself to Fort Victoria. Col. Benjamin Bonneville included all of the fort buildings within the boundaries of the military reservation. That insured that the company would be compensated for its loss. On the last day of the company's stay in Vancouver, the Hudson's Bay flag was raised over the fort; a young employee climbed up and cut the rope, leaving the flag flying.

The Army had already taken over or demolished most of the buildings on the fort and, at last, the remains of the company's presence went up in flames. The fort remained in memory, but not until the late 20th century would the fort be rebuilt.

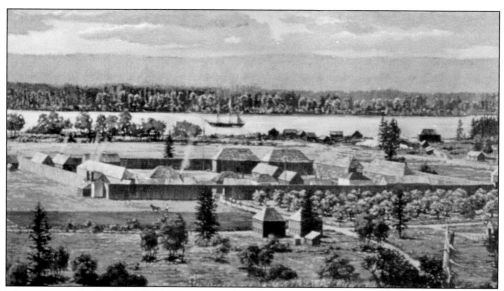

This painting by Richard Schlect portrays the fort at the height of its influence and prosperity in 1845. The Oregon Trail movement was underway and Americans were moving west by the thousands. The demand for beaver pelts had declined along with the population of that animal in the Northwest. The company began to diversify.

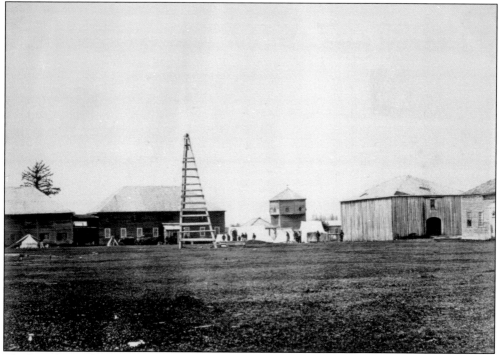

The British North American Boundary Commission set off to survey the borders between the British and American territories in 1857. It arrived at Fort Vancouver in May 1860 and set up camp within the fort walls. In just weeks, the Hudson's Bay Company would be gone forever. (Library of Congress.)

The *Beaver* was a 101-foot-long side-wheeler built in Blackwall-on-Thames in 1833. She came to the fort on the Columbia River in 1836 as a brig and then switched over to engine power. She plied a circuit around the Columbia River and the Willamette Slough. Dr. McLoughlin, the chief factor, never really cared for the ship and she was sent north. In 1888, she went onto the rocks at Prospect Point in British Columbia. Abandoned there, she finally sank in 1892. This image is of a replica built in 1956 and moored at the Vancouver Maritime Museum in British Columbia. (Washington State Archives.)

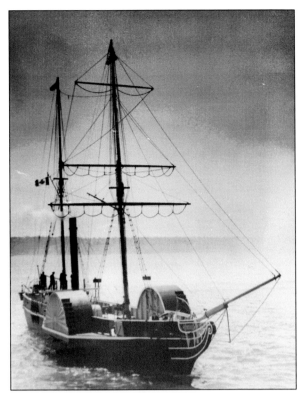

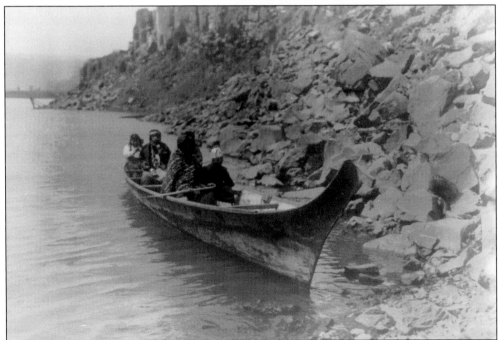

Unchanged since the Hudson's Bay Company's heyday, the masterly crafted canoes of the Chinook were seen on the Columbia River for many years. Lewis and Clark commented on the skill with which they were made, as did gentlemen of the company.

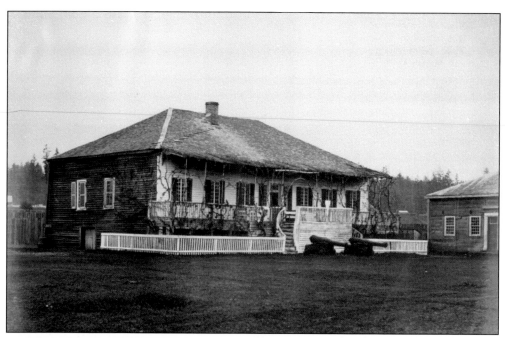

The chief factor's house in the fort, once an elegant residence, was looking increasingly shabby. Since the company's departure, it had been the scene of great entertainments and dinners, as well as shrewd business transactions. After the Treaty of 1846, the company began moving its operations to Fort Victoria. On June 14, 1860, it abandoned the fort entirely. (Library of Congress.)

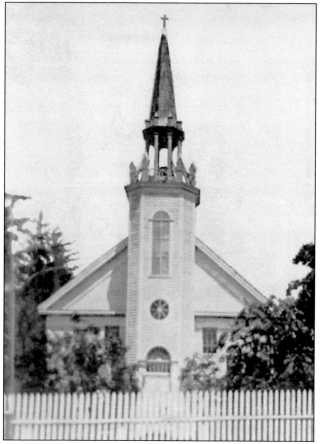

On January 23, 1851, St. James was dedicated by Bishop A.M.A. Blanchet. The church was paid for by the Hudson's Bay Company at the request of Bishop Blanchet's brother, the chaplain to the Catholics at the fort. It would be the seat of the diocese until the cathedral was built downtown in 1885. (Library of Congress.)

The bell tower dominates the central square of the fort, probably as much as it dominated the lives of the workers at the fort. This image was taken during the last year of the Hudson's Bay Company's tenure in Vancouver. The chief factor's house stands on the left, with two never-fired cannons decorating the entrance. The long barracks-like building that holds the central position was for the gentlemen of the fort, rather like a bachelor officer's quarters. (Library of Congress.)

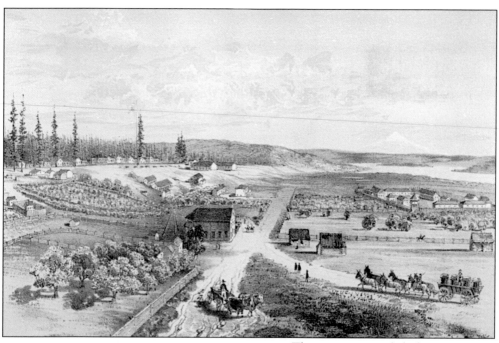

This print was made before cameras came to Vancouver. It was drawn by Gustav Sohon, a young soldier who had emigrated from Prussia at age 17, in 1842. He came west with the Pacific Railroad Survey led by Isaac Stevens. The print depicts St. James in the center, standing on what is now Fifth Street. Officer's Row is to the left, backed by dense forest. The fort lies to the right, with the valley of the Columbia River stretching out beyond.

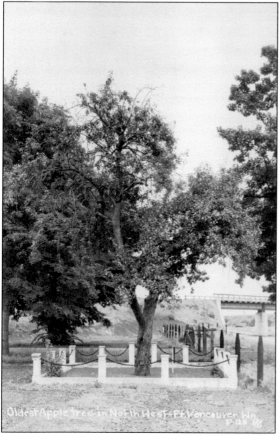

This apple tree is not native to the Northwest. The tree was grown from seeds brought from England in the pocket of a young lieutenant. They had been placed there by his ladylove as a remembrance. The seeds were planted and an orchard grew. In this 1950s image, Highway 14 has yet to be built; the orchard is open to the road. When the freeway was first proposed, the tree was doomed. However, public opinion was quick and fierce and the highway site was relocated.

14

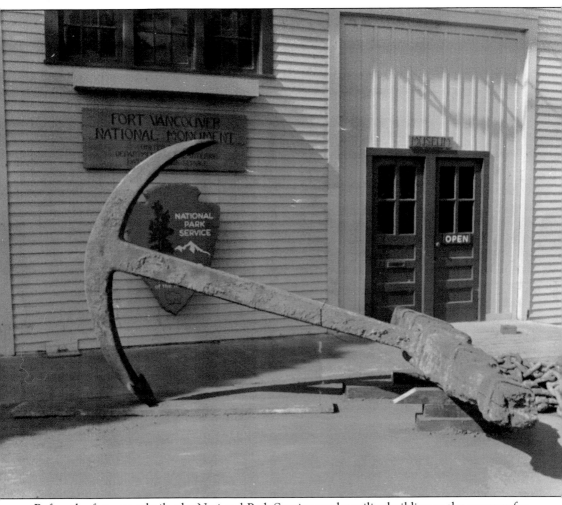

Before the fort was rebuilt, the National Park Service used a utility building as the museum for the site. It was abandoned when the visitor's center on Evergreen Boulevard was built. The huge anchor was found in the Columbia River, but it is unknown which of the ships arriving at the fort lost it. (Greater Vancouver Chamber of Commerce.)

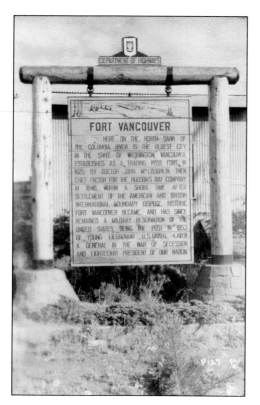

The Hudson's Bay site was designated a national monument in 1948 and was declared a National Historic Site in 1966. That was when this marker was installed off of Washington Street by the Department of Highways. Not long after that, the department was renamed Department of Transportation.

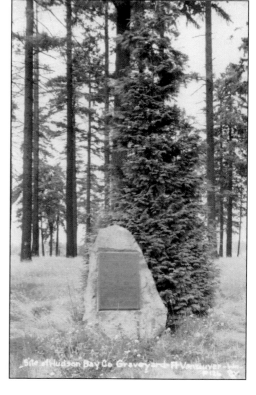

A monument to the original Hudson's Bay graveyard was dedicated on June 12, 1938, by the Daughters of 1812. It was placed northeast of Tenth Street, now Evergreen Boulevard. It honored not only British soldiers who fought against the United States in 1812, but also those who returned here to Vancouver to build the Northwest. Both the cemetery and the monument have vanished.

Two

THE ARMY

On May 13, 1849, the USS *Massachusetts* docked at the Hudson Bay Company's Fort Vancouver dock. Aboard was Bvt. Maj. John S. Hatheway, with Companies L and M of the First Artillery. He was received cordially by Chief Factor Peter Skene Ogden. Thus began the more than 160-year presence of the United States Army in Vancouver. The future of the barracks and the town became intertwined. Prosperity and population would rise and fall depending upon activities at the barracks.

Troops marched off to the Indian Wars, the Civil War, and the Spanish-American War. World War I brought the first of the booms to Vancouver. Thousands of men were employed at the Spruce Production Division, turning out lumber for airplane construction. That effort ended abruptly on November 13, 1918—two days after the cessation of hostilities.

The barracks response to the Great Depression of the 1930s was the Civilian Conservation Corps. The CCC district headquarters, embracing 44,100 square miles of Oregon and Washington, was organized at the Vancouver barracks under the command of Gen. George C. Marshall. It remained there until World War II.

During World War II, the barracks were a transfer point and a training base; and, for a time, a prisoner-of-war camp was sited in a hangar on the airfield and later in Camp Hatheway. Today, Clark College stands on the site of Camp Hatheway.

In 2000, under the command of Col. Robert Knight, the base was deactivated. The garrison flag was furled and marched off the base. The regular Army at Fort Vancouver was gone. The reserves remained until May 28, 2012, when they too left. That part of Vancouver's history was gone forever. The land comprising the military reservation is now divided among many entities, including, among others, the National Park Service, the City of Vancouver, the State of Washington, the Vancouver School District, and Clark College.

When the Army arrived in Vancouver, it built nine log cabins on what is now Officer's Row. In this image, the Grant House can be seen on the far right. The small log cabins were referred to by the officers who dwelt in them as "corrals with roofs on them."

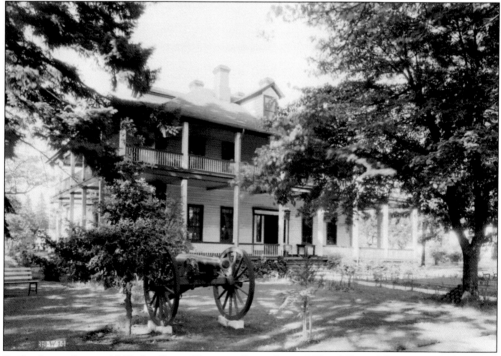

Built of great logs in 1849, the Grant House still stands on Officer's Row. The cannons that were once stationed along the row are gone, except for replicas at the traffic circle. This is the oldest house on the row and was built by soldiers who were paid a dollar a day extra. It was designed to be the commanding officer's residence. Today, it is a popular restaurant.

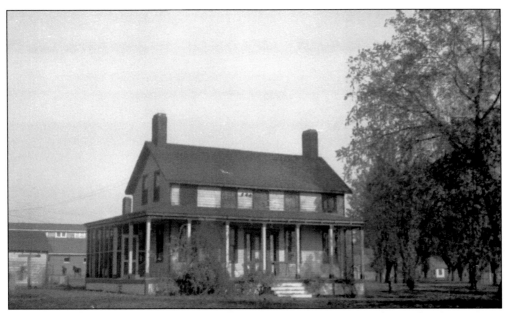

The building that is popularly known as the Grant House was the residence of Col. Benjamin Bonneville during U.S. Grant's term at Vancouver Barracks. Grant lived in this house, called Quartermaster Ranch, with the other quartermasters. This structure was that of a prefabricated house and was shipped from San Francisco by Rufus Ingalls. It was demolished in 1938. (Library of Congress.)

The chapel was constructed in 1892. While all military buildings must follow the codes and designs decreed by the military, chapels may be designed by the builders. So it is with this handsome structure. It was, of course, nondenominational. The building is gone, but the Clark County Veterans Memorial stands in its footprint. (Library of Congress.)

The Army ran on mules. Thousands of the stubborn animals hauled artillery, supply wagons, and materiel until the advent of the gasoline engine. This image is of the artillery mule barn, which was eventually declared obsolete and surplus property. Fortunately, the Washington State Department of Transportation took over the barns and rehabilitated them for its offices. (Library of Congress.)

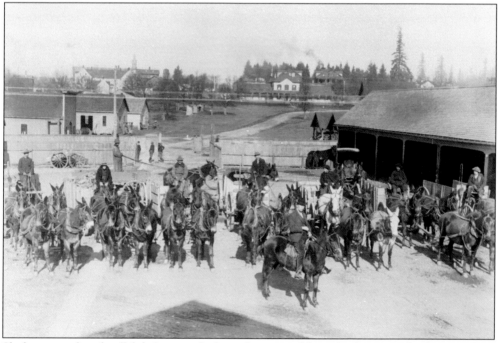

Sleek, groomed, and well-fed, Army mules have disappeared from the American landscape. Along with them have vanished the sounds of hooves, creaking wagons, and, of course, the odors, braying, and the shouts and curses of the muleskinners charged with their care.

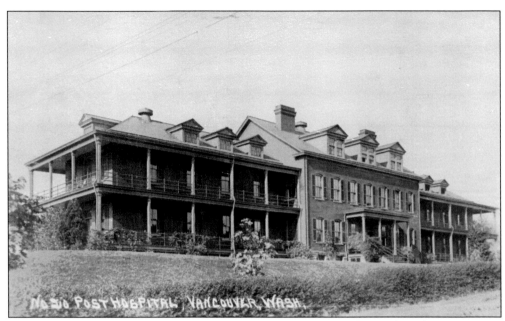

The Post Hospital, built in 1908, at one time was the busiest Army hospital on the West Coast. The building was constructed in the shape of a T, with a wing to the west in the center of the building. When the freeway was built in the 1950s, the wing was moved to the south side of the building. It was used for offices and classrooms until the Army left the barracks in 2000.

The Red Cross built its recovery house across the street from the Army hospital during World War I. It was a place for wounded soldiers to relax in the sunroom, find books, write letters, and socialize. It was no longer needed at this location when Barnes Hospital was opened on the north side of the reservation, and was adapted for other uses. It has been restored and is used for community gatherings. (Library of Congress.)

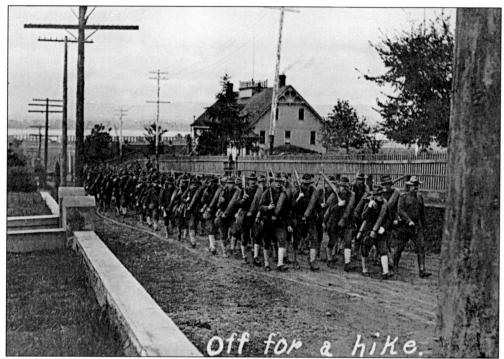

The sight and sound of marching soldiers were common things in Vancouver and Clark County. In this image, 1920s soldiers are marching up West Reserve Street. In the background, the railroad trestle, not yet covered by a beam, can be seen; beyond that, the river is visible.

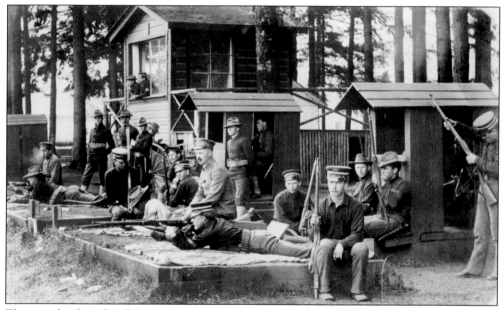

The sounds of gunfire did not raise concern in the city of Vancouver during the decades that the barracks were active. In this image, the rifle range is being used by active-duty soldiers. The range, as well as the frequent crack of gunfire, has disappeared from city life.

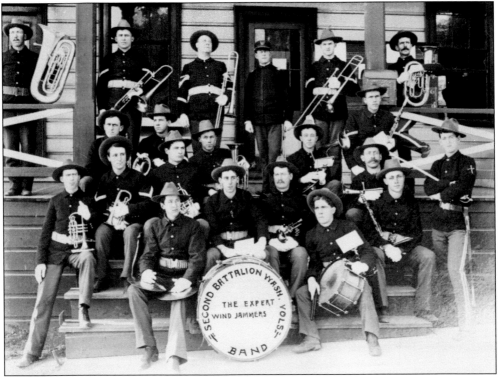

Missing today from the life of Vancouver are the many military bands that played for townspeople and the military alike. This handsome group of musicians is just weeks away from mustering out at Vancouver Barracks in October 1898. The Washington Volunteers would soon thereafter be reorganized as the Washington National Guard.

On a quiet morning, a soldier can be seen in silhouette in the shade of a tree next to the parade grounds. Many of the closest buildings remain, while the more distant have been removed.

A staff car can be seen crossing Grant Avenue. On the parade ground, soldiers perform chores, not knowing that in a few short months the barracks will respond to World War II. Grant Avenue is now Officer's Row, and the road across the parade ground no longer exists.

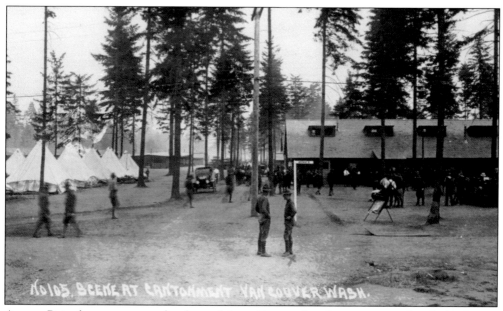

Avenue B, in the cantonment that housed the soldiers and civilians connected with the Spruce Production Division, is a meeting place. The wood-frame building is the YMCA. Hundreds and hundreds of tents housed the men who operated the mill. The division was shut down and dismantled within weeks of the end of hostilities.

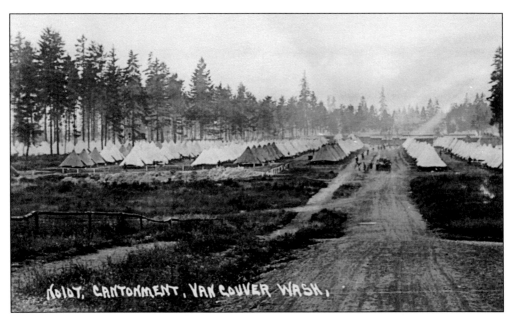

Row after row of tents form the cantonment for the Spruce Production Division. The YMCA building is in the distance. The division was formed, with civilian and military members, in response to labor unrest; it avoided labor unions. The cantonment was situated north of the barracks area in what is now the Clark College campus.

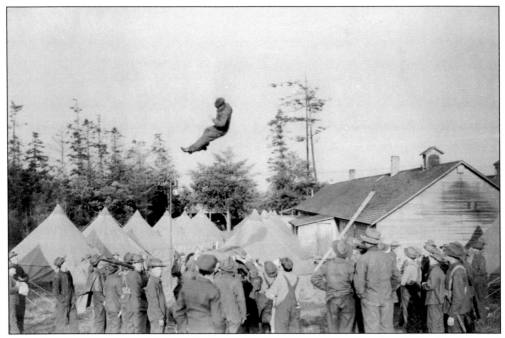

Not all was work at the cantonment. In this image, a new recruit is initiated with the time-honored blanket toss. The group of "old hands" surrounding the event is a mix of military and civilian personnel, as was the division.

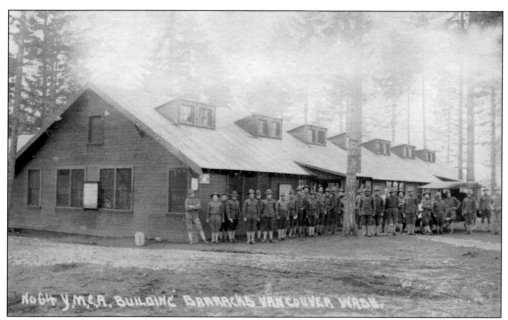

The YMCA building was built to provide services to the civilians and military men stationed in the barracks during World War I. There was a library inside which also sold stationery, postcards, money orders, and snacks.

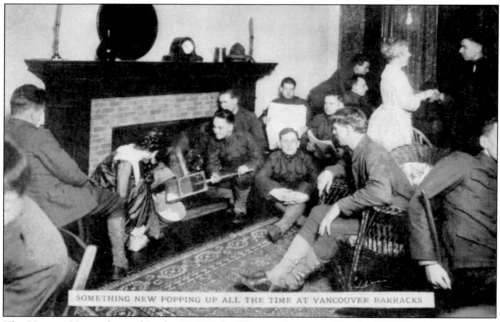

SOMETHING NEW POPPING UP ALL THE TIME AT VANCOUVER BARRACKS

The Hostess House, housed in the YMCA building and managed by the YWCA volunteers, was not just a place for soldiers to relax, write letters, and, in this case, pop corn. In the World War I era, proper women could not go into restaurants unescorted. The Hostess Houses were places for wives, mothers, and sisters of servicemen to meet with them and, perhaps, say their farewells to young men being sent out to war.

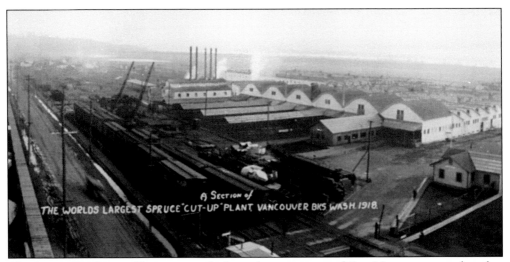

A Section of
THE WORLDS LARGEST SPRUCE "CUT-UP" PLANT VANCOUVER BKS WASH. 1918.

The Spruce Production Division stood where the reconstructed Fort Vancouver stands today. Spruce was the preferred material from which to build airplanes—not only for Americans, but other Allies as well. The world's largest spruce mill sprang into being at the barracks; and thousands of men, civilian and military, came into the forests of the Pacific Northwest to fulfill that need. Two days after the armistice of November 11, 1918, the mill was closed and the disposal of its effects began. The railroad line that curved up from the main line stayed for a few years, but it too was removed in time.

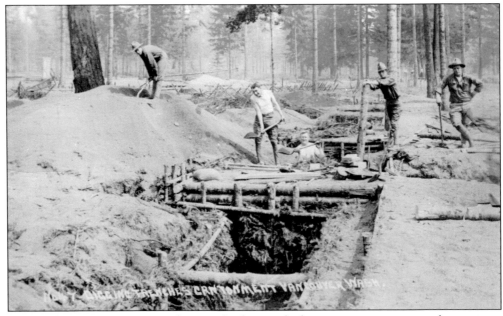

Digging the cantonment is a euphemism for digging the latrines, a necessary part of preparing a camp. These men seem to be handling the situation well.

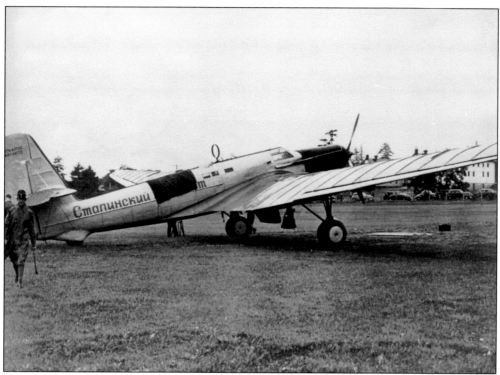

This Tupolev ANT-25, a Soviet aircraft, landed at Pearson Field on the morning of June 20, 1937. The nation had been following its progress by radio. In this image, there is a row of civilian cars parked beyond the fence of Pearson Field, onlookers anxious to get a glimpse of history in the making. The aviators—Valesy Chkalov, Georgi Baidukov, and Alexander Belniakov—were at General Marshall's house, enjoying a bath, new clothes, and a hot breakfast. The media storm was about to hit.

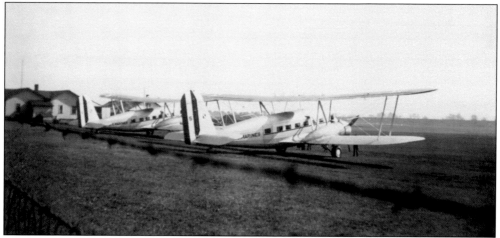

On October 10, 1937, just a few months after the Soviet aviators had returned to their home, two United States Marine Corps planes stopped for a visit at Pearson Field. These are Curtiss-Wright R4C Condors. There were very few built, since, as biplanes, they quickly became obsolete. This is the Marine Corps' total fleet. One of them would be outfitted for use in Adm. Richard Byrd's Antarctic expedition. It is still there.

The Tree Army, part of the Civilian Conservation Corps, was formed at the height of the Great Depression and continued until World War II. Young men from families on relief were recruited to work in forests and wilderness areas for $25 per month, of which $20 would be sent home. Gen. George C. Marshall was the head of the corps for this area. Lewisville Park and Timberline Lodge are two of the most visible products of the corps. In this photograph, members of the corps work on a forest road. (Library of Congress.)

Several of the houses on Officer's Row were demolished for the freeway and for the construction of Fort Vancouver Way. This house is one of them. It is showing signs of neglect in this image. After World War II, the houses were turned over to the Veterans Hospital and were used as housing for medical staff.

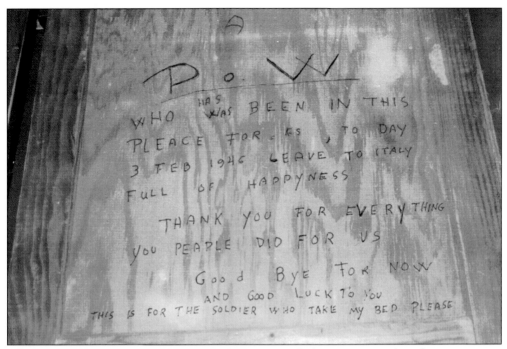

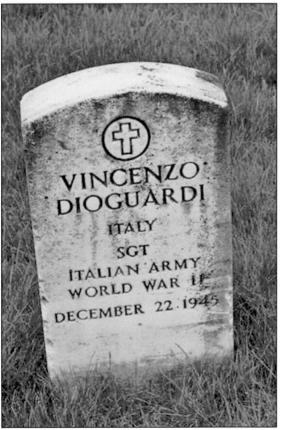

Italian prisoners of war began arriving in 1942; Germans arrived towards the end of the war. When Italy surrendered in 1943, the status of the Italians changed. They were no longer prisoners of war, but cobelligerents. They could work outside the camp. This locker door was found and photographed. The graffiti inside the door reads, "A P.O.W. who has/was been in this pleace for a [illegible] to day 3 Feb 1946, leave to Italy full of happyness / thank you for everything you people did for us / Good bye for now and good luck to you / This is for the soldier who take my bed please."

Not lucky enough to go home, Vincenzo Dioguardi, an Italian prisoner of war, rests in the Post Cemetery. He died of injuries sustained in a traffic accident in Portland when the jeep in which he was a passenger hit a truck. He and an American soldier had been Christmas shopping. Near Dioguardi's grave lie two German prisoners of war.

Three

THE RESERVE

Most of the Military Reservation was turned over to local governments after World War II, when most of the land was declared surplus by the federal government. With a few exceptions, the Army now would confine itself below Officer's Row. Many of the buildings on the row were used by the Veterans Administration.

One of the first things needed was access across the reservation. Soon, Mill Plain Road and McLoughlin Boulevard would join with Tenth and Eighteenth Streets on the west. Fort Vancouver Way sweeps across both of those arteries, and across Officer's Row; unfortunately, two of the old houses were sacrificed for that road.

There were many schemes for redeveloping the land for civic use. A new civic center was envisioned, with a city hall and a jail. The Coast Guard wanted to build dependent housing there. New schools, apartments, shopping—one after another, the suggestions poured in. At last, a plan called "A Park for the People" was developed. From that came Central Park.

Great swathes of open space are preserved, today known as the Great Meadow. The community enjoys the playing fields and playgrounds that were placed throughout the park.

Hudson's Bay High School, Clark College, and Marshall Community Center were soon built, but in their turn, they too, have changed. The original buildings would be unrecognizable today. Only the regional library and the public utilities building remain unchanged.

The waterworks that served the Army are still there, in Waterworks Park, but the open reservoir and the graceful buildings have been replaced with more utilitarian structures.

The sprawling Barnes General Hospital, built for the military, was converted into the Veterans Hospital. The buildings were temporary, quickly built and inefficient. None of those structures remain today, instead replaced by large, modern buildings. Clark County's massive public health building anchors the northwest corner of the reserve.

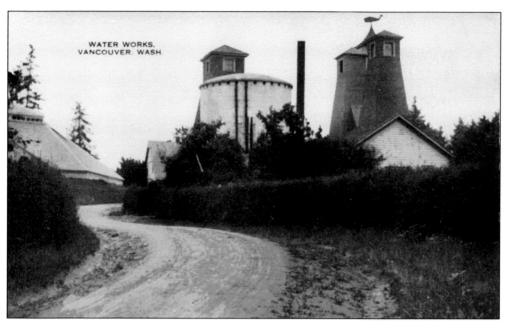

The Army found deep wells with abundant fresh water at the very highest point of the military reservation. It dug wells and erected sturdy buildings around the pumps and wellhead. Today, there are 10 wells at that same site; they are still supplying water to the city of Vancouver.

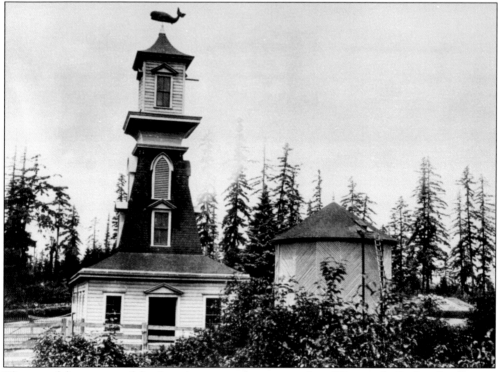

The graceful structures of the Army's waterworks are gone from Waterworks Park today. Five air strippers were installed in 1993 to clean pollution from the groundwater. Since September 11, 2001, the water facilities have been secured and a walk through the field is no longer possible.

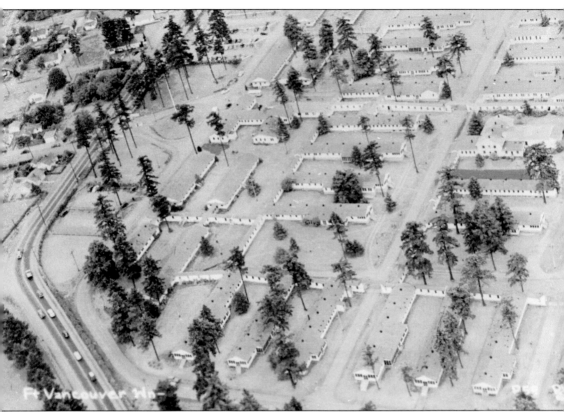

Barnes Hospital was named for the Army surgeon Gen. Joseph K. Barnes. He was the surgeon general from 1864 until 1882 and had the dubious distinction of being in attendance at both the assassination of Abraham Lincoln and that of James A. Garfield. This aerial view shows the size of the installation. The road on the left is Fourth Plain Road, curving onto West Reserve Street. Fourth Plain Road would not connect with western Vancouver until the freeway was built.

Barnes Hospital was converted to a veterans hospital after World War II ended. This postcard view of the administration building from Fourth Plain Road is probably the facility's most enduring memory for most Clark County residents.

The chapel at the hospital had the most ardent supporters hoping to preserve its structure. It was an interdenominational chapel used by chaplains of all faiths during its time of service. Many military couples remember the chapel in the hospital as the place where they were married. Others, sadly, remember that is was just across the street from the Post Cemetery.

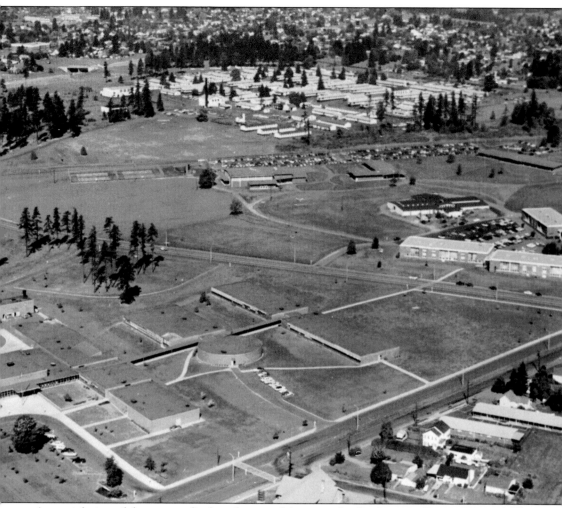

An aerial view of the reserve displays the use of the space. In the distance, Barnes Hospital fills the land. A strong effort was made to build housing for the Coast Guard personnel and their dependents next to the hospital, but that plan failed. The Coast Guard soon left Vancouver. In the foreground, East Reserve Street runs past the new Hudson's Bay High School. Newly constructed McLoughlin Boulevard intersects that street, and Clark College occupies the area to the north. Fort Vancouver Way has been built through the reserve. The parking lot has plenty of spaces available.

The upwelling of civic pride that accompanied the acquisition of the military reserve led to the populace voting in a variety of bond issues for civic amenities. One of the needed facilities was a pool gymnasium complex. The Marshall Community Center and its pool met those needs. Shortly thereafter, the Luepke Senior Center joined the structure. As the population grew, more recreation facilities became needed. Another bond by the people expanded and modernized the center. The original structure is recognizable under the new construction. (Greater Vancouver Chamber of Commerce.)

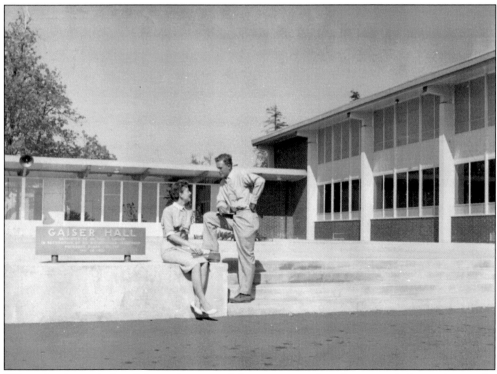

When the Army declared the major part of the reserve surplus, there was designated room for education. This gave Clark College its first permanent space since its inception in 1933. The college now had the land, but not the money. The voters of Clark County approved a bond measure in 1956 that financed the construction of the school. Gaiser Hall, named after the former school superintendent and college president, was completed in 1956. The front entrance, shown here, has disappeared under additions and remodels. (Clark County Genealogical Society.)

Four

UNDER THE FREEWAY

A visitor was overheard remarking, "This city starts at Fifth Street! Where's the First, Second, Third, and Fourth?"

Those streets were there once; they are now buried under the freeway interchange from I-5 to and from State Route 14, as well as the approaches to the Interstate Bridges. Downtown was a busy, thriving area of shops, liveries, hotels, and government offices. Lodgings once stood on the river's edge, including the Hotel Columbia and the St Elmo. There were restaurants and saloons—perhaps there were too many saloons—or poolrooms. That was reflective of the city's status as an Army town. The Log Cabin Saloon catered to soldiers, as did the poolrooms and, yes, bawdy houses. Unfortunately, no photographs of that particular endeavor seem to have survived.

When the Carnegie library opened on New Year's Eve 1909, at Sixteenth and Main Streets, many grumbled at its location so far out of town. Even then, however, many merchants were moving north, scarred by the Great Flood of 1892 that had inundated lower Main Street. They did not realize that floods of that magnitude were not an ordinary occurrence.

The first Interstate Bridge debouched onto Washington Street and caused little disruption to the city. The second bridge, in the 1950s, and the subsequent federal and state highway construction buried great swaths of real estate. The people of Vancouver resolutely turned their backs to the river and moved north. The return to the river would have to wait until the last quarter of the 20th century.

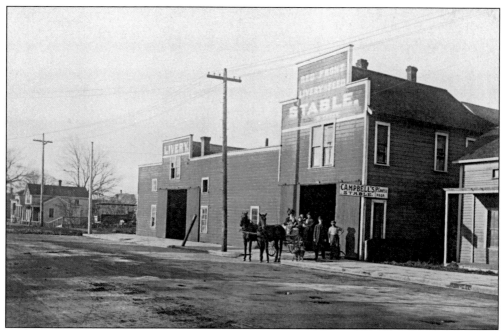

The Red Front Stables was a livery hoping to serve the travelers coming off the ferry. In this image, a family is taking the reins of a fine-looking pair of horses and is ready to go about their Vancouver business.

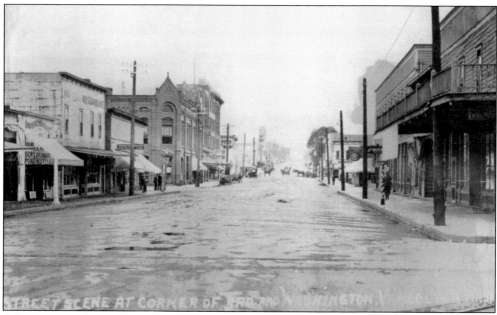

After a rain, puddles reflect the sky in this 1908 view of Washington Street from around Second Street. Automobiles are just making themselves seen and heard on the streets of Vancouver. South of the post office building, where there will soon be car dealers, stand a realtor, Watters Restaurant, and the Golden Rule Confectioners Shop. North of the post office is the *Columbian* newspaper office, and rising in the distance is the St. James steeple. Across the street, a long-vanished symbol stands—a barber pole on the sidewalk.

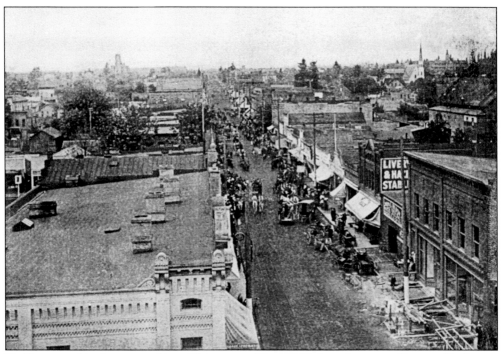

Traffic was and is always a problem. This postcard from 1909 shows heavy traffic caused by horses and wagons on Washington Street. The tie-up was perhaps exacerbated by the new construction going on in the building at lower right. On the horizon, left of center, is the steeple of St. James. To the right of center is the wooden spire of the First Presbyterian Church.

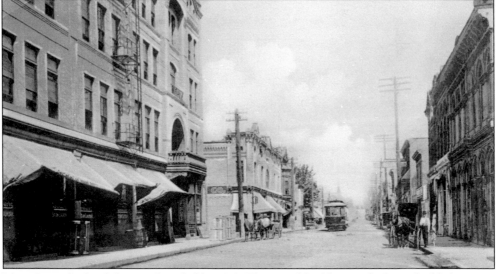

Main Street had a definite urban feel by 1910. The grand building with the arched balcony on the left is the Columbian Hotel. The Hidden family, local entrepreneurs, built it at the corner of Second and Main Streets. A steam laundry takes up most of the ground floor of the building. The Baltimore Restaurant fills the block across the street. The streetcar line was just finished in 1910, going all the way to Sifton. Here, at Third Street, a streetcar prepares to make its turn toward Washington Street.

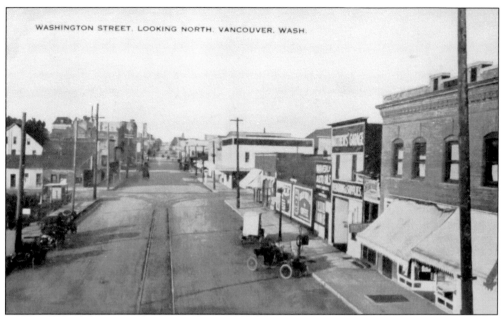

Washington Street has begun to change in this 1913 photograph. Horse-drawn conveyances are still using the roads, but automobiles are beginning to gain the upper hand. Matthews' Garage, on the right-hand side of the street, is a harbinger of things to come. Across the street, an empty lot has begun to fill.

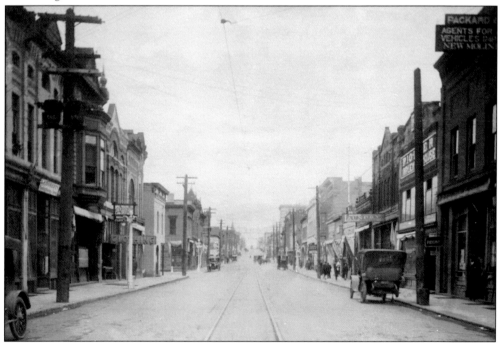

In 1915, no horse-drawn vehicles can be seen on Main Street, in this view looking north from Third Street. The tribulations of the automobilist are apparent in the flivver at the side of the street, up on jacks with the right rear tire missing. Sturdy buildings line the street, each with an elaborate facade and decorative masonry. (Michael Jaffe collection.)

"A policeman's lot is not a happy one," according to the lyrics in Gilbert and Sullivan's *The Pirates of Penzance*. In this case, patrolman Winfield Gasaway stands next to the Star Sand Company after a silver thaw in 1910. The company built a dock south of First Street, near Main Street. (Jennifer Peterson collection.)

The grand St. Elmo Hotel, at Fourth and Washington Streets, dominates the road. The south end of the building is the Vancouver Post Office, with the *Columbian* newspaper office tucked in between. The new Interstate Bridge is in the background. The hotel would not survive freeway construction.

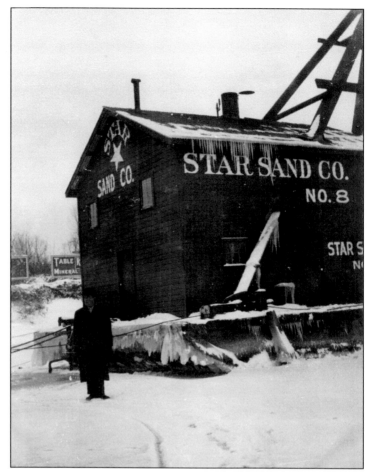

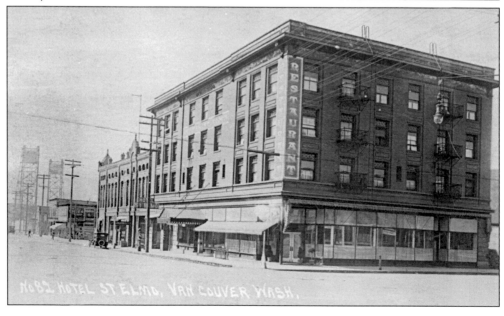

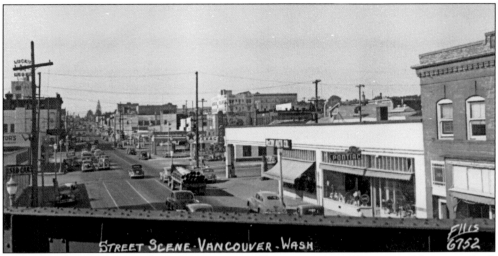

The railroad overpass from which this image was taken is gone now. No one would want to climb the berm for this view. All of this has disappeared. In this photograph, Lineham Studebaker stands on the left, at Third Street, with a 1936 Studebaker truck at the curb. The grand building beyond it is the post office. Behind and to the left of the post office is the Hop Gold Brewery. This area is automotive centered, but streetcar tracks still head down Washington Street toward the bridge.

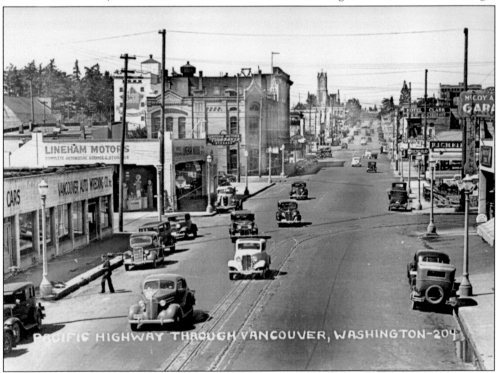

In this image from the early 1940s, the brewery, now Lucky Lager, dominates the skyline. The Gothic Revival front of the post office has, unfortunately, been modernized. Visible above the Texaco station, the Evergreen Hotel is at the corner of Fifth and Main Streets, and across from it stands the Wolf Building. Still devoted to the automobile, the face-liftings of the dealership continues. The streetcar tracks have disappeared.

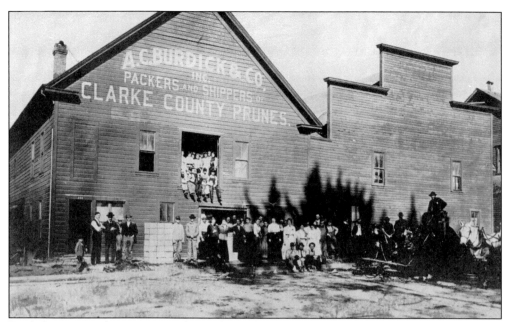

Burdick Prune Packing was one of several such businesses devoted to moving the prune harvest out of Clark County. It stood at First and Washington Streets, and was one of the first to disappear under a roadway when the Interstate Bridge was begun in 1914. The managers moved into the Vancouver Ice and Coal Company on West Seventh Street.

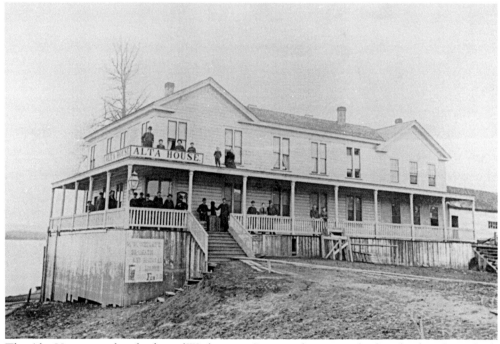

The Alta House stood at the foot of Washington Street, right next to the ferry landing. It was built by Esther Short and her sons. In this image, an advertisement for a "dramatic and musical event" on February 28 hangs on the wall and the cast of the show lines up on the porch for a portrait.

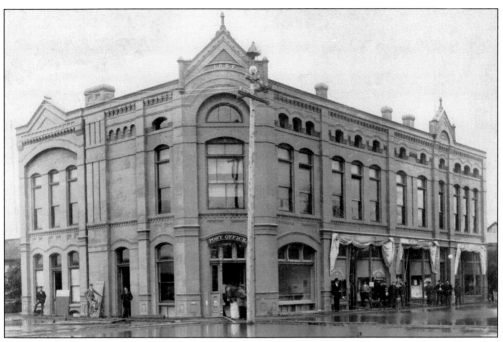

The post office at Fourth and Washington Streets was a grand building built of brick in this Gothic Revival style. The Odd Fellows lodge was above and shops filled the ground floor. Unfortunately, it was prone to flooding in the days before the dams.

On the Washington Street side of the post office was the small office that contained the *Columbian* newspaper. Bicycles are leaning against the front of the office, ready to take paperboys on their rounds.

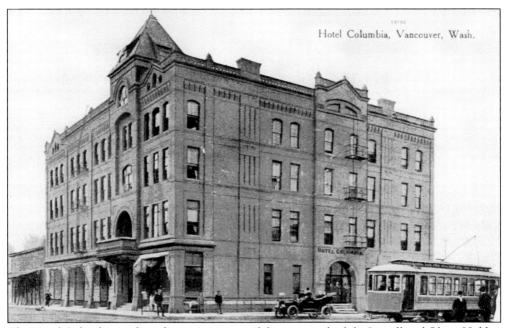

The Hotel Columbia, with its distinctive pyramidal tower, was built by Lowell and Oliver Hidden in 1891. It was built with Hidden bricks, of course. It stood for many years at the corner of Main and Third Streets. In this view, a streetcar waits on the Third Street side before making the turn onto Main Street.

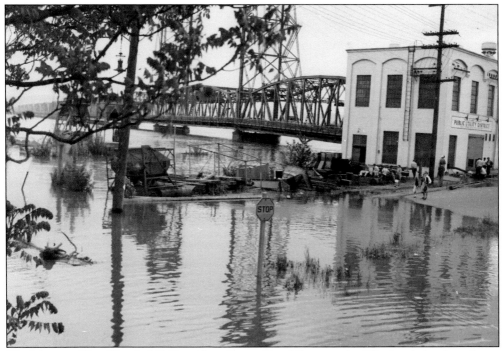

The Memorial Day Flood of 1948 produced a wealth of photographs. The lonely boulevard stop sign in the center of the image controls the traffic on Main Street at Second Street. That section of Main Street would eventually disappear under the freeway. (Washington State Archives.)

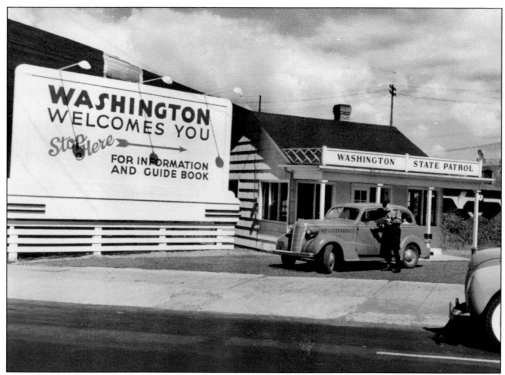

Far friendlier than a reflective green Welcome to Washington sign on the bridge, this personal welcome station was at 103 Washington Street. The Great Depression was well underway, so perhaps there were not too many tourists heading north. The structure was also the office of the state agricultural inspector, so it did double duty. (Washington State Archives.)

Not as personal, but still inviting, this tourist information building in the 1950s stood beside the highway, south of the Evergreen overpass. At this point, the chamber of commerce was operating the station, assisted by volunteers. As the freeway grew, it too would be buried. (Greater Vancouver Chamber of Commerce.)

Five

DOWNTOWN

If drivers follows most highway signs that point them to City Center, they will not find downtown Vancouver. When the freeway was cut through downtown in the 1950s, the off-ramp to the downtown from the north or south was eliminated. The closest exit into the city center is at Mill Plain Road. Only from the west, on Highway 14, the off-ramp is at Sixth Street, which will take the traveler into the heart of the city.

The core of the city, Esther Short Park and its environs, was neglected for decades, strangled by its lack of access. Once a retail hub, it followed the fate of most other freeway cities. Shopping malls opened on the east side of the city and, most tellingly, across the bridge in sales tax–free Oregon.

To revive the area, urban renewal, which some call urban removal, was brought into the downtown core. Forty acres of residential and retail space were cleared and rezoned to light industrial. Much of that space stood empty for years.

Legalized card rooms opened to replace the dwindling retail. The facades of vintage buildings were replaced with modern sidings and overlays. The downtown core gradually became unrecognizable and unwelcoming. Everything south of Fifth Street was removed for the freeway interchanges.

The brewery, once a source of employment, was closed and stood abandoned and desolate at the core of the city. Property values around the derelict plummeted. The downtown that many remembered vanished.

Downtown revitalization has again changed the face of Vancouver. The brewery is gone, new businesses have opened and closed, and others have taken their place. New buildings have risen and old ones have disappeared.

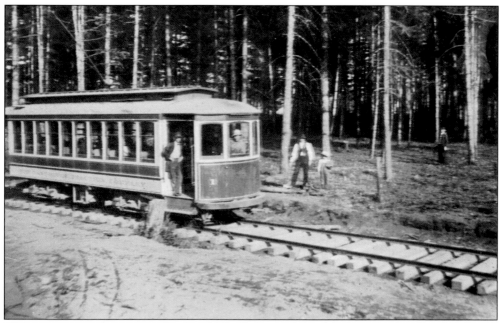

The streetcar system was completed in 1910 all the way to Sifton from the ferryboat landing at the foot of Washington Street. When the Interstate Bridge was completed, it met the Portland Street Railway, which ran across the bridge from Portland. The streetcar line ended in 1926 as the passion for automobiles removed its passenger base. (Michael Jaffe collection.)

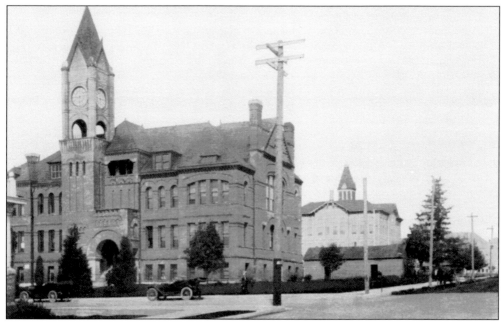

This courthouse was built after fire destroyed the preceding structure in 1892. It stood at the corner of Eleventh and Franklin Streets until the present-day courthouse was built in 1941.

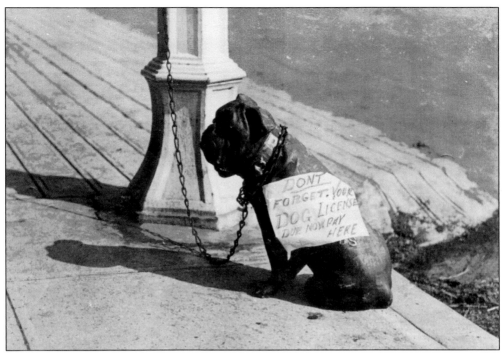

Undoubtedly owned by a former US Marine, this 1910 bronze statue of a bulldog stands guard by a lamp post and does double duty by warning passersby that their dog license fees are due. Alas, the dog has vanished without a trace. (Jennifer Peterson collection.)

Lowell Hidden owned a property with a good, wide band of clay on it. He opened a brickyard at what is now the intersection of Main and Fifteenth Streets in 1871. Most of the historic buildings downtown, such as the Academy and the Carnegie library, were all built of Hidden bricks. Eventually, the brickyard was moved to Twenty-sixth Street and Kauffman Avenue; it closed in 1992. (Hidden Farms collection.)

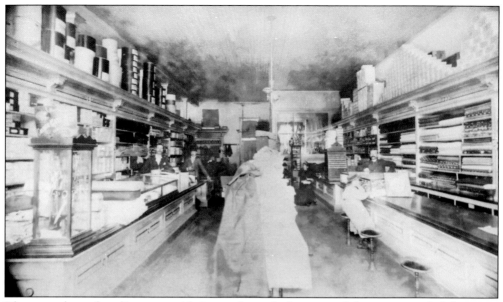

The general merchandise store, with its neatly stacked items and the attentive clerk hovering behind the counter, has vanished in the day of the big-box store. This business, at Fifth and Main Streets, was owned by Sohns and Schuele, who were brothers-in-law. Louis Sohns was a onetime mayor of Vancouver. David Schuele was also an elected official, serving as county treasurer in 1867.

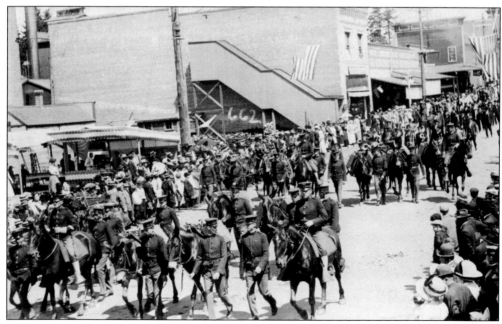

Soldiers, horses, and mules—Fourth of July parades not only featured the bands and marching troops, but the pack mules as well. On the left, a refreshment stand has been set up and decked out in bunting.

Seventh Street at Broadway Street in the 1930s boasted the Red Ash Seed Co., with a display of plants for sale on the sidewalk. Across the street, Sparks Motor Company displays the latest Dodge autos. The Sparks building now houses a bar, but Red Ash has vanished.

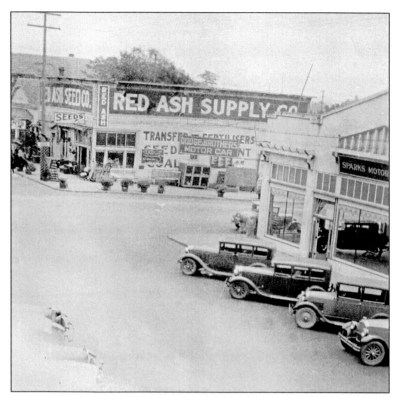

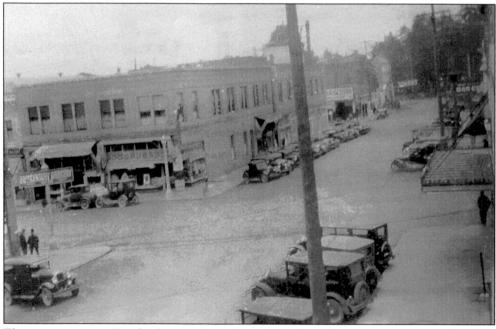

The corner opposite Sparks Auto, at Seventh and Broadway Streets, was home to a drugstore and a grocery store. Backing in to park is not a new innovation; in fact, it was once the norm. The tall trees in the background are in Esther Short Park, and the tower of the brewery rises above the rooftops.

While the downtown post office on Daniels Street looks much the same today, the verdant lawns and trees that once surrounded it have given way to asphalt and parking. The awnings on the windows have also disappeared, though perhaps that is not a bad thing.

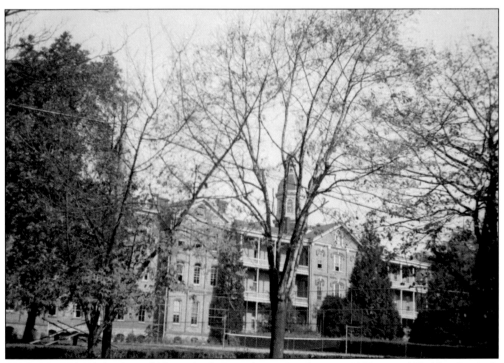

Mother Joseph of the Sacred Heart built Providence Academy in 1873 out of Hidden brick. It was to serve as an orphanage as well as a school until 1969, when the school was closed and the building scheduled for demolition. Instead, it and the seven acres around it were sold to the Hidden family. Today, it is considered to be part of the Historic Reserve.

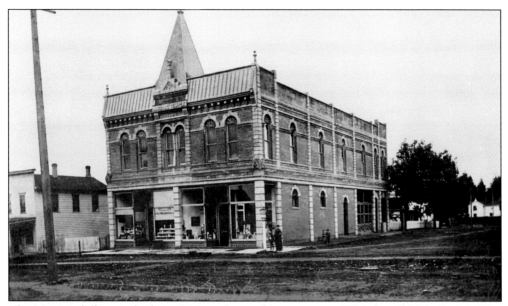

The Masonic lodge was built in 1885 on the southwest corner of Eighth and Main Streets. The lodge room was upstairs, with shops on the ground floor. In the beginning, there was one lodge, Washington No. 4, and then Mount Hood No. 32 was begun. The building was thought too small, so it was sold and a new temple built in Hazel Dell. A modern bank building now stands on this site. (Vancouver Masonic Center.)

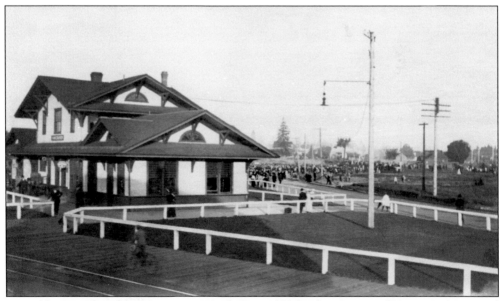

It would appear that the entire town turned out in 1908 for the opening of Vancouver's new and modern train depot. It would be foolhardy today to gather that many people in what has become one of the West's busiest train yards. Vancouver had long been isolated from the transportation network, but in that year, the north bank line to the east was completed, and the North/South Line Bridge connected those routes.

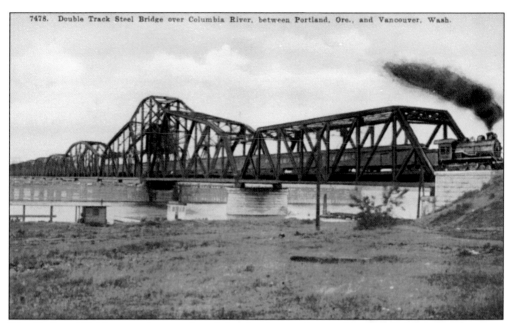

7478. Double Track Steel Bridge over Columbia River, between Portland, Ore., and Vancouver, Wash.

The Railroad Bridge was the wonder of the day. It was designed by Ralph Mojeska, the same man who would later design the Interstate Bridge, and it was a twin to one that spanned the Willamette. If electric power failed, it could be opened by hand. It still can. When the bridge was completed, sirens, horns and whistles blew, to the consternation of the populace, who were not told of the impending event. A parade was scheduled later.

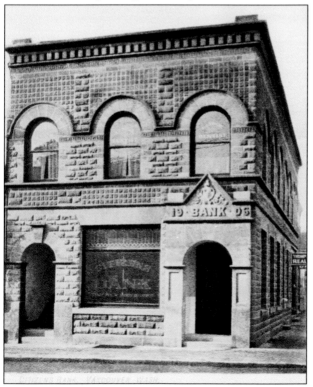

The Citizens Bank at Sixth and Main Streets later became the First National. The building itself still stands, although it is unrecognizable today. A few years after this 1905 photograph, a terra-cotta tile facing was applied over the brick-and-stone exterior and a clock was installed on the corner. It is in the Washington Heritage Register as it is, however, because that "modernization" is now historic. The Firehouse Glass studio now occupies the space.

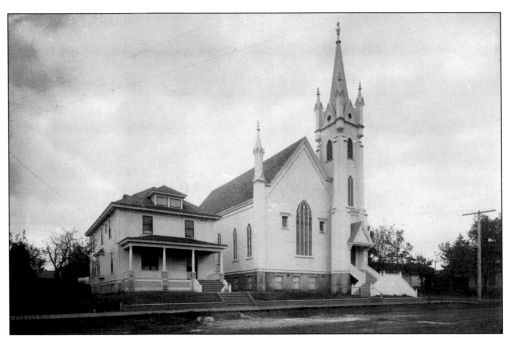

The First Presbyterian Church and manse were charming structures built of wood. On a cold January night in 1911, the town was awakened by the bells and horns of the fire brigade rushing to the scene. Unfortunately, the church could not be saved and the manse was badly damaged. (First Presbyterian Church collection.)

The Presbyterians wasted no time replacing their ruined church. The cornerstone for the replacement, this time of brick, was laid on June 14, 1911, and the first services held on the first anniversary of the disastrous fire. After the congregation moved to its new church on Main Street, this building, for a time, became the Columbia Art Center. When that failed, it became commercial space, and now serves as home to another church.

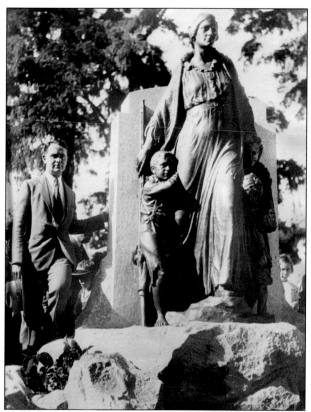

Avard Fairbanks stands beside his new creation, *Pioneer Mother*. It has just been unveiled in Esther Short Park on September 7, 1929. Edward and Ida Crawford donated $10,000 for the statue. Fairbanks was a well-known sculptor, noted for the Oregon Trail sculpture in Boise, Idaho, that same year, as well as many spiritual works around Temple Square in Salt Lake City. The statue of the Angel Moroni, which crowns many Latter-day Saints temples, is his design as well. Perhaps his most familiar work, however, is his design for the hood ornament on the Dodge Ram pickup.

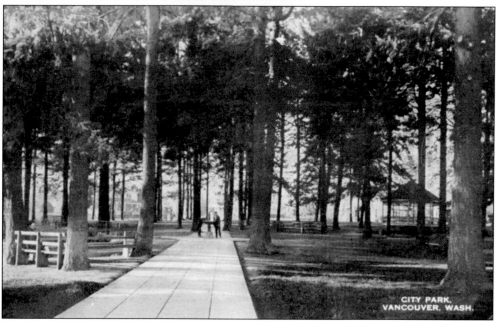

Esther Short Park was simply known as City Park for many years. In this image, the great stand of trees is still intact. They would eventually fall to storms and age and be replaced. The drinking fountain in the center of the park would also disappear.

The brewery dominated the skyline for decades. The first brewery was established in the early 1850s. The label that was brewed might change, but the beer continued to flow. After World War I, Prohibition shut down the brewery and it became a soda water bottling plant. When 3.2 percent alcohol by weight beers were allowed in 1933, a street party was planned, but there was no beer. In the 1980s, the brewery was bought by a competitor, and it was closed. It stood, dilapidated and decaying, for years. In 1995, the brewery and the old city hall were finally demolished. The smaller building nearest the camera was once city hall and the police station. (*Columbian* newspaper.)

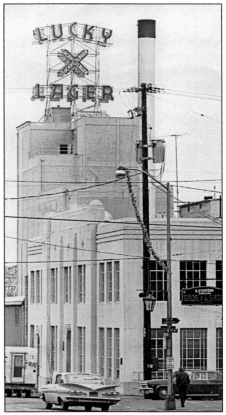

Before it was Lucky Lager, Hop Gold was the brew that came out of the Vancouver Brewery. Indeed, Vancouver Brewery was its first name. Star was the lager first produced. Hop Gold came along in the 1890s. When Dewey defeated the Spanish at Manila, 300 cases of Hop Gold were dispatched for the relief of the troops. Interstate took over in 1939, producing Lucky Lager. At the end, the plant turned out many brands of beer, including that with the stark black-and-white label "Beer."

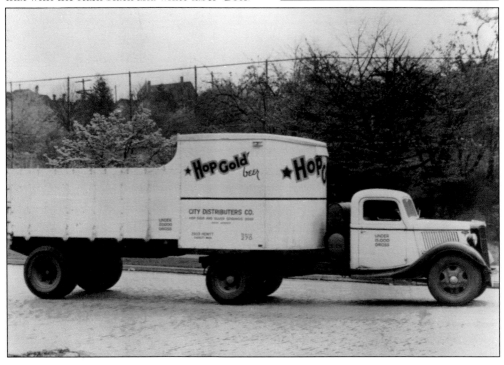

The First Congregational Church occupied this imposing building that stood at the corner of Fourteenth and Main Streets. It has vanished; the IQ Credit Union now stands at this site. Then again, the intersection of Fourteenth and Main Streets has also vanished. It is now part of the Mill Plain couplet eastbound. The church has moved to Hazel Dell, on Northeast Sixty-eighth Street.

Lloyd DuBois operated an early newspaper, the *Independent*, under the name Pioneer Printing. Jesse "Ken" Durkee took over the business in 1945, and moved it to 113 West Seventh Street. After World War II, business boomed as soldiers came home from the war and new businesses opened. Durkee moved to a much larger location at 1315 Columbia Street. It was an innovative business, with modern equipment. It could not, however compete against the computer, and the business closed in 2009.

The Log Cabin Saloon catered to soldiers. It stood at Fifth and Main Streets The log fronts and painted tree branches were an icon of prewar and pre-Prohibition Vancouver. Unfortunately, the Log Cabin could not make it as a café after the Volstead Act took effect; it dried up.

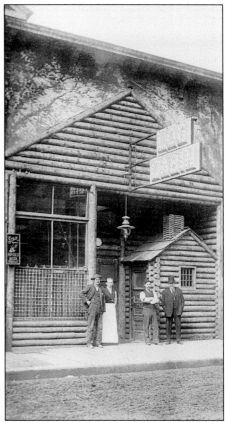

The Columbia Club was organized by a group of young businessmen in a residential building at Tenth and Main Streets. Originally, it was a private club, but more and more, its activities became the fostering of business. The name was changed to the Commercial Club. It evolved into the chamber of commerce.

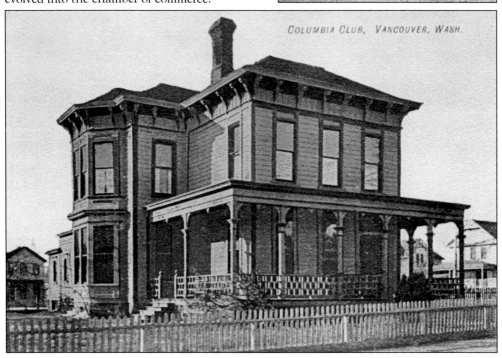

COLUMBIA CLUB, VANCOUVER, WASH.

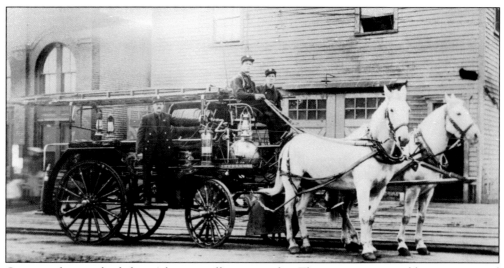

Gone are the sounds of a horse's hooves galloping to a fire. There was some grumbling as motorized fire equipment appeared; the men that tended to the animals lost their jobs, as did the horses. (Jennifer Peterson collection.)

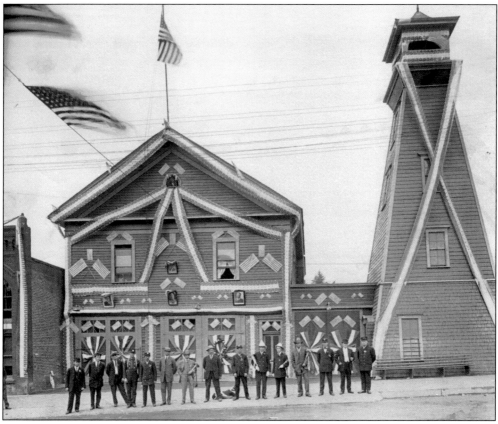

The fire department is gloriously bedecked for the Fourth of July in 1910. Portraits of presidents, festooned with ribbons, hang on the wall. The firemen, with helmets and bugles, line up in front. The small windows in the fire tower are part of the city jail. (Jennifer Peterson collection.)

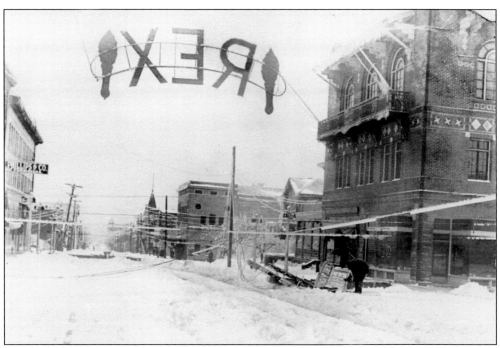

February 1916 brought a tremendous ice storm to Vancouver. In this image of the aftermath, the Elk's Lodge at Evergreen and Main Streets dominates the scene, but farther down is the vaudeville theater that would be converted to retail space. The Rex was a movie theater that was just north of its sign arching across the street.

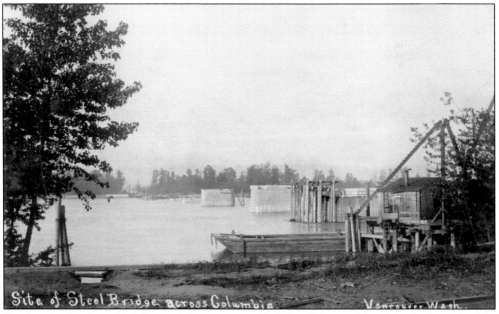

Bonding by Clark and Multnomah Counties enabled the construction of the bridge. The first shovelful of dirt was turned in March 1915. Work continued as heavy pilings were driven into the riverbed and the buttresses constructed. The unbroken view of the forests on Hayden Island disappeared forever. (Michael Jaffe collection.)

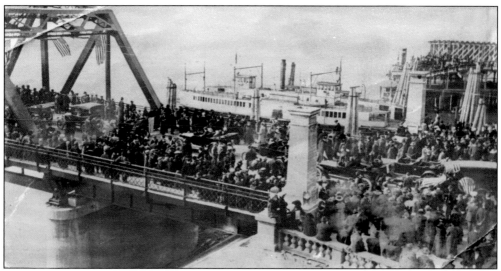

This photograph of the opening of the Interstate Bridge was taken from the roof of the Public Utilities District building. The first day's income from tolls was $287.75. Over 4,000 people crossed the bridge that day, as well as 500 automobiles or trucks. The newspaper noted that only 78 animal-drawn vehicles crossed, "showing the steady decline in the use of the horse." Fifteen head of cattle were herded across the span. Their drovers paid the toll for the cows.

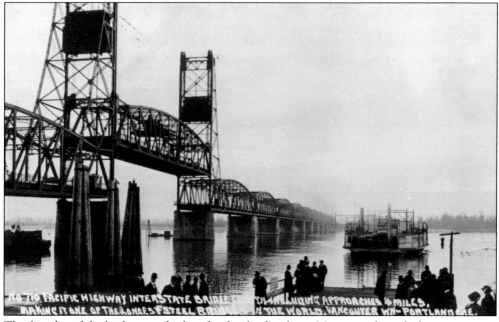

The first day of the bridge was the last day for the ferryboat. Many people took the opportunity to ride the ferry on that last day, using the boat in one direction and the bridge for the walk back home. In this image, the ferry leaves the dock at the foot of Washington Street for the last time as the bridge towers over the river.

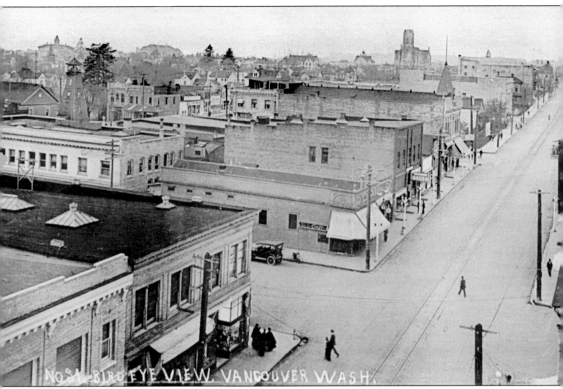

This image of Main Street from Seventh Street is from a postcard mailed in 1916. There are no traffic signals and only one automobile is visible. A trio of nuns from the Academy chats on the corner. Further up the street, the spire of the Masonic lodge can be seen, beyond that is the bulk of the Elks lodge. A streetcar in the distance rumbles toward the camera among scattered strollers. The fire tower can be seen above the buildings on the left.

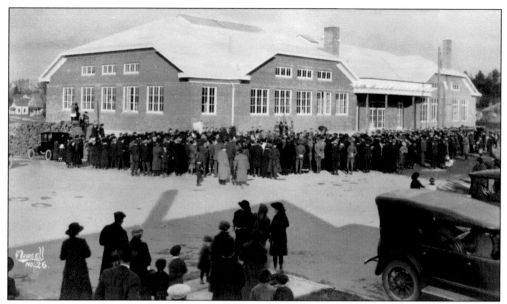

Smith-Reynolds Post No. 14 was formed after World War I and was named for Arthur G. Smith and Emory C Reynolds, young soldiers sent from Vancouver Barracks to the trenches of Europe. They died there a week apart, Smith on August 10 and Reynolds on August 17, 1918. In 1921, the Legion bought the entire block, from Broadway to C Streets and Thirteenth to Fourteenth Streets, to be the site for a clubhouse. At the grand opening, pictured here, more than 3,000 people attended.

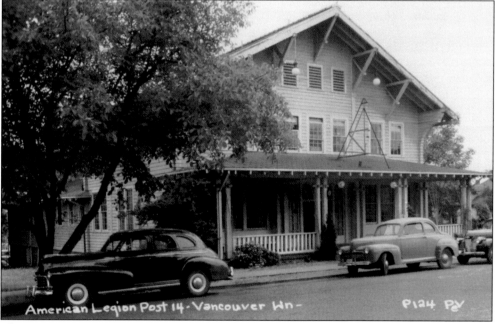

The expense of maintaining the elaborate memorial building was more than the American Legion could manage. It sold the building to the city and bought this structure at the corner of Seventh and C Streets. In 1924, Congress recognized the American Legion and the Vancouver Legion was the 14th to receive its charter. (Smith-Reynolds Post No. 14 American Legion collection.)

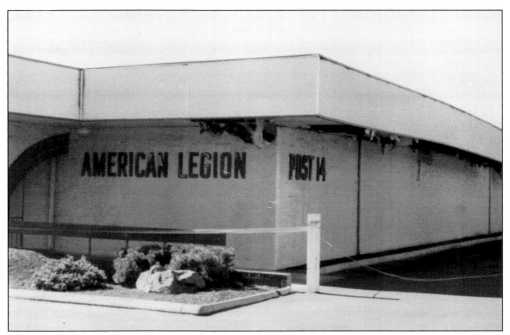

In 1973, the Legion bought property at Sixth and Esther Streets and built a new and modern post building. This image, in 1989, shows a corner of the building after it was damaged by fire. The structure was rebuilt, but eventually it would be sold, and the post moved its meeting place out of downtown. (Smith-Reynolds Post No. 14 American Legion collection.)

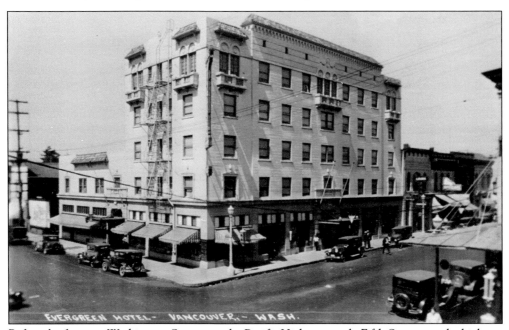

Before the freeway, Washington Street was the Pacific Highway north; Fifth Street was the highway east to Walla Walla. The chamber of commerce decided that a good hotel would encourage travelers to stop in the city. In 1927, it began to raise the money by selling shares. It needed $138,000, and rose $143.000. With a huge celebration, the Evergreen Hotel opened on March 17, 1928.

St. Joseph's Hospital's cornerstone was laid on November 7, 1909. It was operated by the Sisters of Providence, and named for the patronymic of Mother Joseph, who had died just seven years before. The building was constructed of bricks from the Hidden Brickyard. The structure, which stood at Twelfth and West Reserve Streets, was demolished after the new hospital on Mill Plain Road was built.

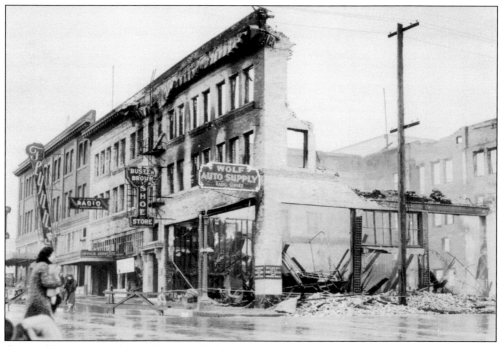

On a cold January night in 1928, the Blaker Building at Ninth and Main Streets was destroyed by fire. It would be rebuilt, but as a single-story commercial building rather than the imposing brick structure that it had been. Vancouver and Clark County were plagued by fires in the 1920s and 1930s. (Michael Jaffe collection.)

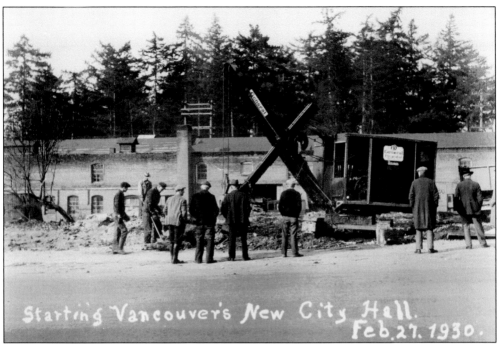

Starting Vancouver's New City Hall.
Feb. 27. 1930.

Mayor John P. Kiggins had ordered the construction of city hall just after the Wall Street crash in 1929. He wanted it designed like an office building in case the city had to sell it in a hurry. In this image, equipment breaks ground for construction. Behind the group is the brewery storage building. The trees rising beyond are in Esther Short Park.

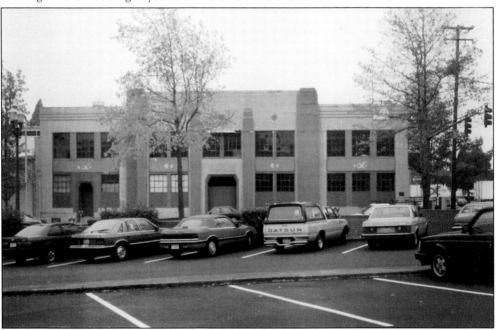

The old city hall, now a part of the abandoned brewery, stands forlorn and desolate at the corner of Seventh and Washington Streets. It will soon be gone and eventually be replaced by the Vancouver Centre building. (City of Vancouver.)

The First Methodist Church stood for many years at Ninth and Columbia Streets. The congregation grew, and, in 1946, it bought 10 lots at Thirty-second and Main Streets from the Washington Pythian Home. Members laid the cornerstone for their new church in 1949, and the first services were held in August 1950. This building was subsequently demolished in the 1950s.

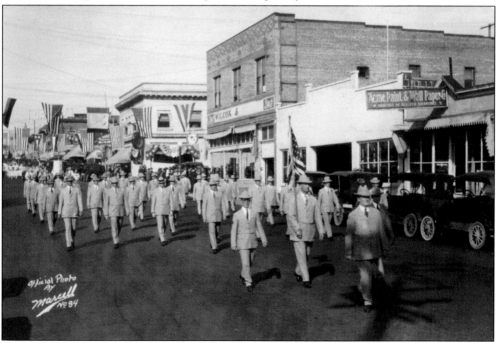

The Prunarians were founded in 1919 to promote the welfare of Clark County and the prune industry. The group was composed of the movers and shakers of the town. They successfully lobbied the county to build an auto camp on Main Street at Burnt Bridge Creek. It was named Prunarian Park. Here, they lead a Fourth of July parade on Washington Street at Sixth Street. In 1926, they voted to boost all agriculture, not just prunes, and to remove the 100-member restriction. It was the beginning of the end for the "Full of Prunes" gentlemen.

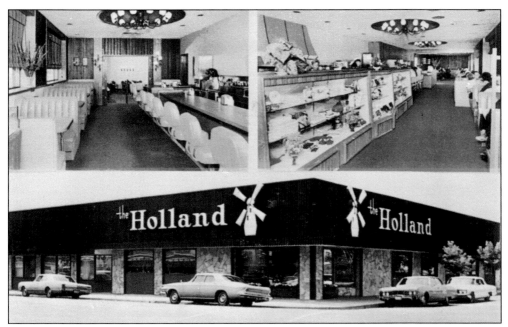

This postcard will cause nostalgia in many Vancouverites. The Holland Restaurant grew out of the creamery. It started out serving sandwiches, then meals. The restaurant grew and prospered for many years. The Holland was the meeting place for Vancouver business and social networking. It closed in 2001.

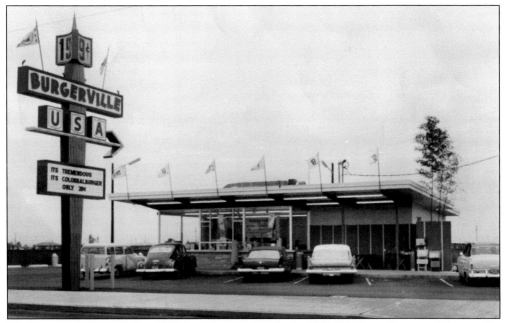

The downtown Burgerville is festive on its opening day in 1962. This was the second Burgerville built by George Propstra. Propstra owned the Holland Restaurant, which had grown out of the Holland Creamery founded by his father, Jacob. It was the last of the walk-up hamburger restaurants owned by the company. The building was sold and was demolished in 2012. (Burgerville USA Collection.)

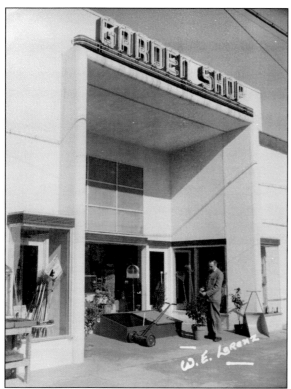

Luepke's Garden Shop opened as the city was booming in the 1940s. Unfortunately, the boom began to spread north and east. The shop was no longer in a good location for a home improvement business. It is still there, however, now as an extension of Luepke Flowers at Thirteenth and Columbia Streets. (Luepke Florist Collection.)

The gnarled old elm in front of the historical museum (and former Carnegie library) was a beloved tree. Planted during or just after World War I, the old tree withstood ice storms, winds, climbing children, and Dutch elm disease. It would have stretched across Main Street, but buses kept its reaching branches knocked off. It was diagnosed with root rot in 2003, and, as shown in this image, was propped up for a few years, a tree on crutches. When it began to shift in 2008, it was removed and a landmark on Main Street vanished.

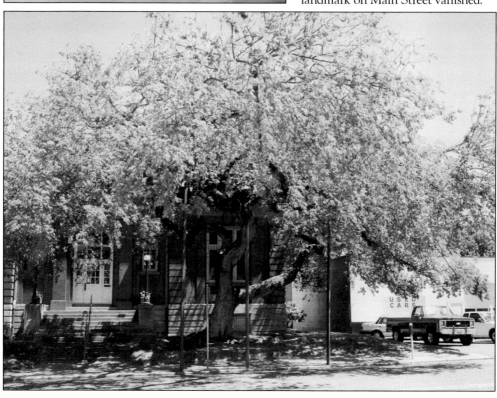

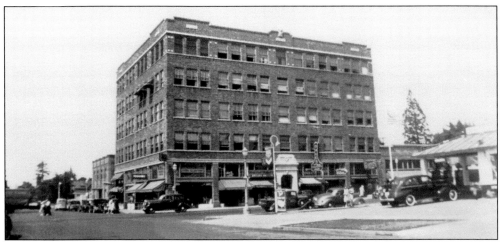

Construction of the Arts Building at Eleventh and Main Streets began in 1928. Hadley's Department Store would later move in and then vanish. The Standard Oil station across the street replaced Limber's Funeral Parlor and would in its turn be replaced by a bank, which would disappear. The site is now occupied by the Main Place building.

Victor Limber rented the imposing estate of the late Dr. Henry Wall at 1111 Main Street. There, he opened his funeral parlor in 1912. He advertised that he was a proud graduate of the Pennsylvania College of Embalming. He continued in business until the 1940s, when Evergreen Staples Mortuary bought his business. (Michael Jaffe collection.)

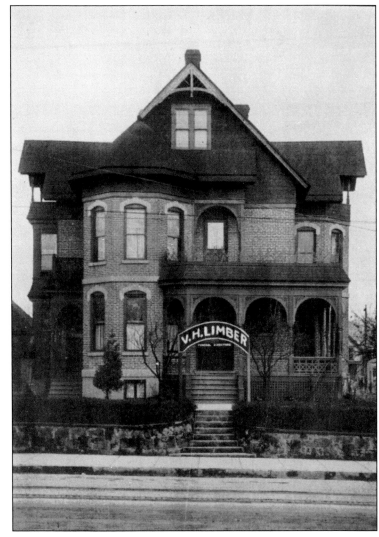

Wright and Grandy Motor Company appears desolate in this 1940s photograph. It is wartime, and there are no new cars to be had. There were used cars to be sold and a brisk business in repairs. The sale of new cars would come back, of course, with a waiting list for new Fords. The business then became Marshall Ford. For a time, the structure was called the Marine Building, as it was the headquarters for State Steamship Line, which was a lumber transport and passenger line. Today, it is part of the Vancouver Marketplace.

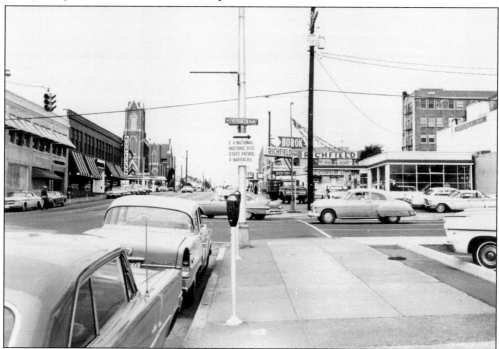

The intersection of Washington Street and Evergreen Boulevard was referred to as Car Corner. The Ford Agency stood on the northwest corner, with service stations, garages, auto parts dealers, and used car sales surrounding the area. On the corner light post is a small sign that points the traveler to the "F.V. National Historic Site State Patrol and V Barracks." Most of this has disappeared, as have the tail fins on the cars. (National Park Service.)

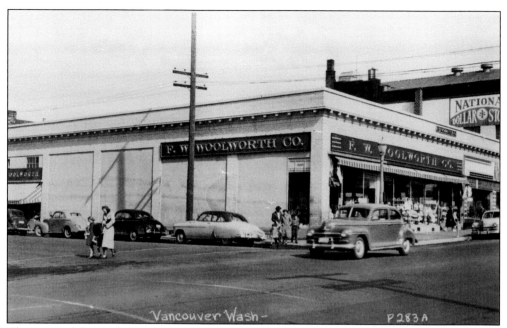

Three now-defunct chains stores stand together on Main Street: the Woolworth's, its neighbor Sprouse-Reitz, and the National Dollar Stores. All have disappeared from the urban landscape in the United States. Woolworth's was the boutique of choice for schoolchildren buying Christmas gifts for family.

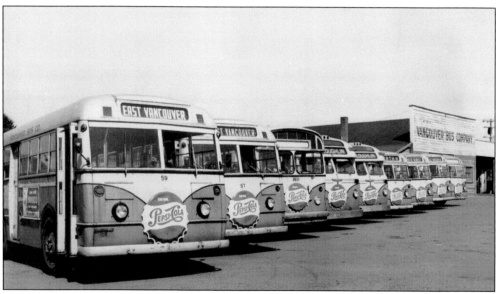

Vancouver Bus Company had its bus barn at 2500 East Thirty-third Street. That had been the carbarn for the streetcars. As were most transit companies, the bus company was privately owned and served only the city of Vancouver. It approached bankruptcy in 1976. In a countywide election, a transit district was formed and CTran was organized in 1981. (Corwin Beverage Company.)

Anderson's gas station offered crankcase service at the corner of Thirteenth and Main Streets. The building behind it is the Hidden House. In 1934, the station was moved to the corner of Fifteenth and Main Streets. The station has vanished, and so have the rather attractive buildings it once occupied. (Michael Jaffe collection.)

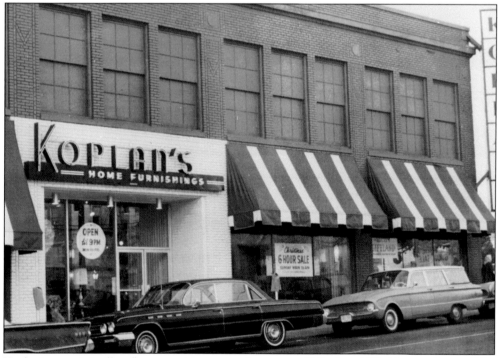

Koplan's was originally a floor-covering store at the corner of Ninth and Washington Streets. The business grew; Albert and Delphi Koplan added window coverings and then moved to Evergreen Boulevard and Broadway Street. The business continued to grow; the owners added furniture and, in 1965, remodeled the building at 1012 Washington Street. Merle and Keith Koplan continued the family business until it closed in 2008. (Greater Vancouver Chamber of Commerce.)

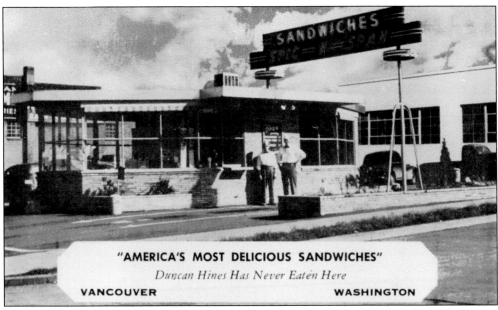

"AMERICA'S MOST DELICIOUS SANDWICHES"

Duncan Hines Has Never Eaten Here

VANCOUVER WASHINGTON

The Spic-n-Span was the ultimate teen hangout for young people from both Fort Vancouver and Hudson's Bay High Schools. The parking lot at Fifteenth and Washington Streets would fill on Cruise Nights. Eventually, Cruise Nights would be ended, but the Spic-n-Span would last for many more years before finally closing in 1999. The building was designed by Day Hilborne, the renowned architect who designed the courthouse. (Michael Jaffe collection.)

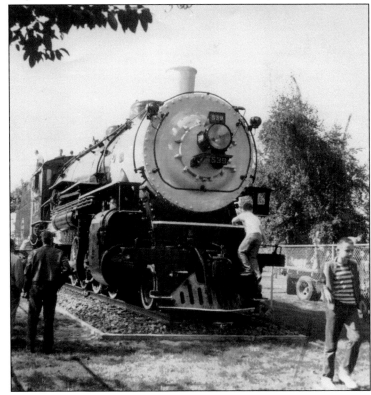

The Mikado Class locomotive, built in 1917, was donated to the city in 1957 by the SP&S Railroad. It moved on temporary tracks from Seventh and Harney Streets to Esther Short Park. The chain-link fence that would be built around it did little to deter determined children from exploration. It stayed there until 1997, when it was taken to Battle Ground to be used on the Chelatchie Prairie Line. When that effort failed, it was sold to the Grand Canyon Railroad, where it remains. (*Columbian* newspaper.)

75

In 1954, the huge air-raid siren was delivered to the courthouse to be placed on the roof. The crane used to lift it broke and gouged a trough in Franklin Street. Eventually, the siren was installed, and was sounded at noon on every weekday for many years. (Washington State Archives.)

The Slocum House once stood at Fifth and Daniels Streets. Charles Slocum was a sutler, that is, a supplier to the Army. He opened a general store in Vancouver as well as one in Boise, Idaho. He also assisted in platting out Boise. This image is of the house in its original place. The neighborhood was filled with old houses, some neglected and others well maintained. All have disappeared. (Library of Congress.)

Thankfully vanished is this experiment in traffic control. With the scramble pedestrian method, vehicles in all directions stopped, and pedestrians could then cross in all directions. Neither walkers nor drivers appreciated this system. It went away. (Good Old Boys Club collection.)

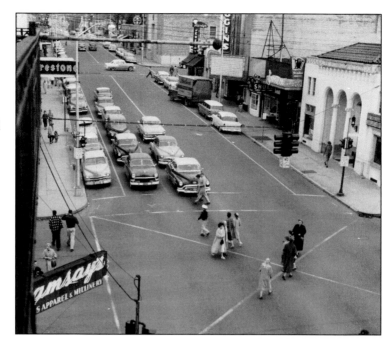

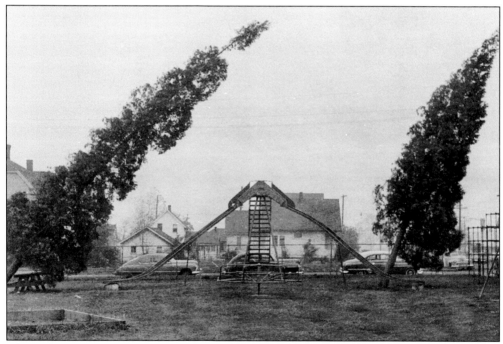

The Columbus Day Storm in 1962 threatens the high slide in Esther Short Park. Thousands of trees were lost during the great windstorm that lashed the Northwest with the highest winds ever recorded for the area. The slide would survive the storm, but its days were numbered.

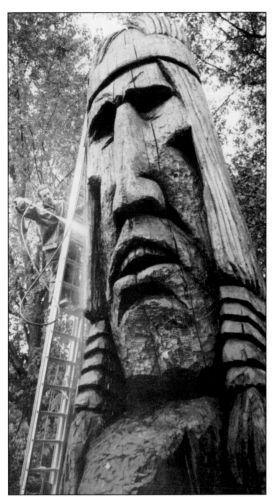

Peter "Wolf" Toth carved giant heads of Native Americans in all 50 states. He called them Whispering Giants, and sought to call attention to injustices suffered by the tribes. In this image, the carving is getting a cleansing shower. Unfortunately, Vancouver's carving was of spruce, and, over the years, slowly rotted away. There are very few of the massive sculptures left. (*Columbian* newspaper.)

Dine in a railroad car! That was George Goodrich's idea behind the Crossing Restaurant. With several passenger cars and a caboose, it stood between Seventh and Eighth Streets at the railroad tracks. It was a popular spot for a while, especially for business lunches. It changed hands several times and then finally closed. It was demolished in 2006. (*Columbian* newspaper.)

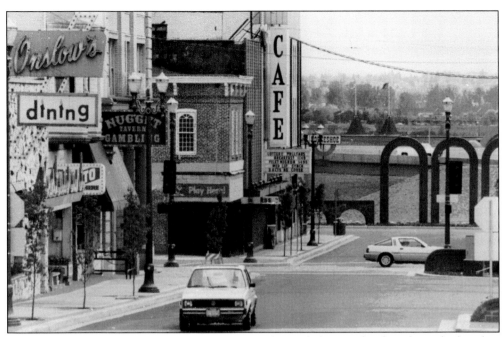

At the foot of Main Street in this 1985 photograph stand the new brick arches. The last days of the gambling era in downtown are evident. The Frontier Club is gone completely, Onslow's restaurant has been replaced by other businesses, and the card rooms have moved to La Center. (Good Old Boys Club collection.)

Vancouver was changed drastically with the advent of the gambling era. On Sixth and Main Streets, the bank is now the Ford Building and card rooms surround Onslow's restaurant. Onslow's was a downtown icon, operated by several generations of the Onslow family before it finally closed in 1996. (Good Old Boys Club collection.)

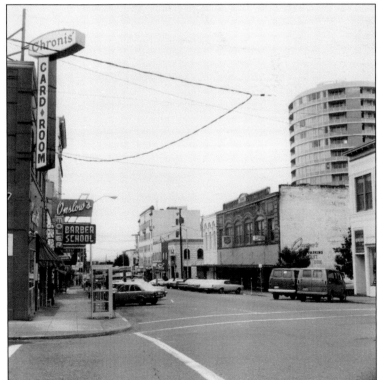

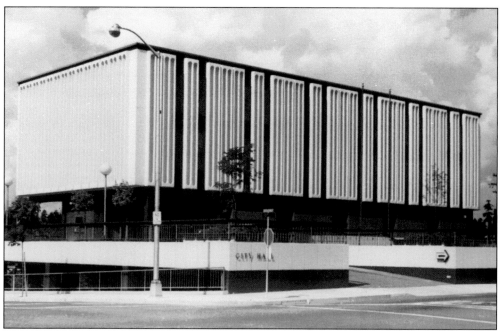

The 1966 city hall was built on land leased for a dollar a year from the Vancouver School District. It was originally designed to be expanded to five stories as the city grew. Unfortunately, when that time came, building and seismic codes had changed so much that that could not happen. In 2011, the city government relocated to a new location at Sixth and Esther Streets and this building reverted to the school district. (City of Vancouver.)

The Labor Temple was remodeled into the police station when city hall was constructed. The jail was in the basement. Municipal court was at that time in city hall, so a tunnel was built under C Street to connect the two. The police station was demolished, but construction was delayed. When it began, a man was discovered living in the tunnel, having made a cozy home for himself, complete with electricity tapped from the former city hall building.

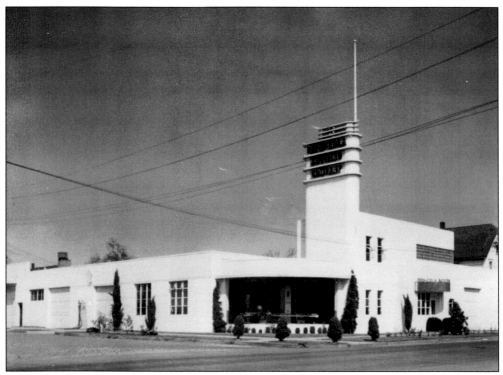

The Pepsi-Cola Bottling Works were very much a part of Vancouver's life for decades. It is a family-owned business through generations of the Corwin family. The building still stands, but Pepsi has moved its operations to the town of Ridgefield. (Corwin Beverage Company collection.)

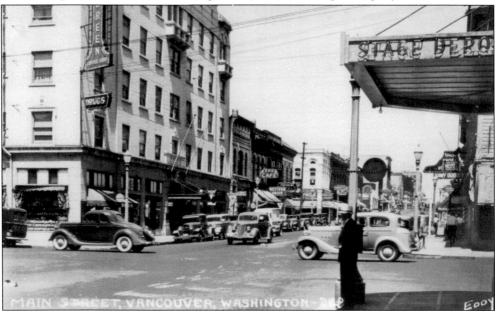

At Fifth and Main Streets in 1936, the large number of new cars would belie the Great Depression. Today, the gentleman leaning against the light post in front of the Stage Depot would be standing next to the brick arches.

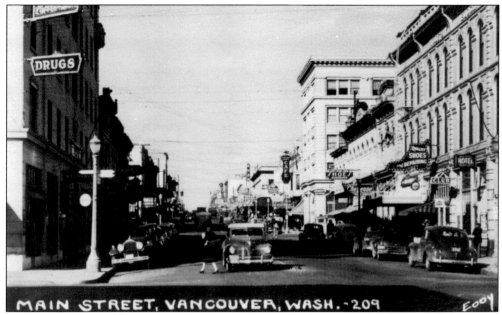

MAIN STREET, VANCOUVER, WASH. - 209

Main Street from Fifth Street is a wilderness of signs in this 1938 image. All of the buildings on the right hand side of this photograph have disappeared. The First National Bank, now the Heritage building, can be seen halfway down the block.

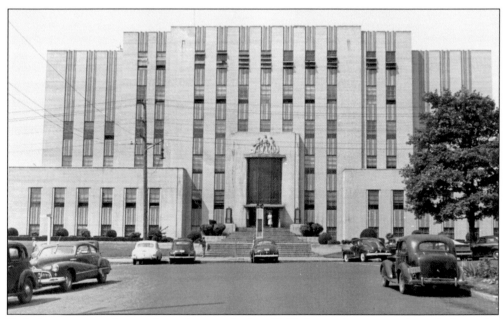

Today's county courthouse, shown here in the late 1940s, boasted a concrete bas-relief over the door, affectionately termed the "Buckskin Brigade." It was accidentally destroyed by cleaning in 1978 and was removed. Public opinion and donations caused a new one to be sculpted. The sculptor, R.W. "Bill" Bane, used Rev. Joe Smith, pastor of St. Luke's Lutheran Church, as a model for the figure on the far right. Rather than look towards the river as do the other figures, that one's head is turned toward his church. The parking, alas, is gone forever.

Six

UPTOWN

The original townsite plan of Vancouver was roughly in the form of a right triangle. The hypotenuse of that triangle would be the west boundary of the military reservation. One leg would be Main Street and the other Nineteenth Street. The uptown business area is above that point, although today's reference would be Eighteenth Street, now called McLoughlin Boulevard. From here, the view of uptown can be carried all the way north on Main Street to the city limits. Uptown's commercial section is an example of early-20th-century streetcar line development. The streetcar system ran up and down Main Street and then westward on Thirty-third Street to St. Johns Road, where it curved onto the Fourth Plain Road and continued to Sifton.

The south end of uptown is a busy, eclectic mix of small businesses, cafés, and antique and specialty shops. Above Fourth Plain Road, Main Street and Broadway Street join and continue as Main Street to the city limits. At one time, there was a huge racetrack that covered what is now the site of the School of Arts and Academics, and would have reached into the freeway. Where the streetcar would have made the turn east, there is a cluster of medical and health-related structures. Commercial endeavors surround Thirty-ninth Street, which was once called Summit Road because it was the highest point of Vancouver. The road then falls away to the Covington House and then to the braided concrete of Interstate 5. A look with imagination can still see the old Pacific Highway stretching off into the distance.

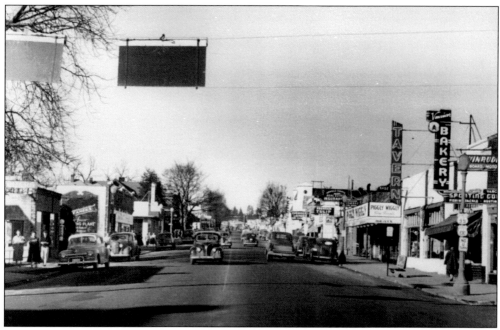

In the heart of the retail uptown area are Nineteenth and Main Streets. In this photograph, taken in the early 1950s, it is a bustling urban street. Missing today are the many high school students on the sidewalks headed home at the end of the school day. The neighborhood grocery stores, such as the Piggly Wiggly, have also passed into oblivion.

The 2200 block of Main Street is almost unrecognizable today compared to this 1950s image. Superior Feed stands next to Pieren Paint store. Classen Ellecric is a neighbor to McVicker's Barbershop. (Oliva family collection.)

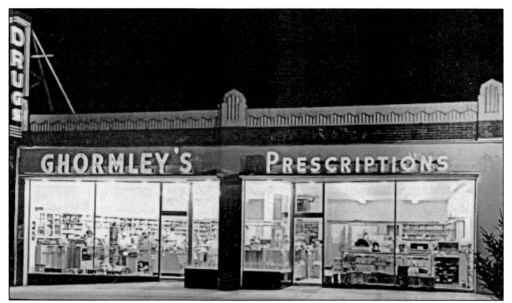

Ghormley's was one of many owner-operated drugstores that at one time dotted shopping streets. As the large chain stores developed, business declined in the smaller stores. Clyde Harris Ghormley opened his pharmacy at Twenty-fourth and Main Streets in 1931. His son, John Thomas "Tom" Ghormley, inherited it in 1960. By then, the large chains had begun to open in Vancouver. Business steadily decreased, as did that of many other small independent pharmacies. It closed for good in 1967 after 36 years. (John Thomas Ghormley collection.)

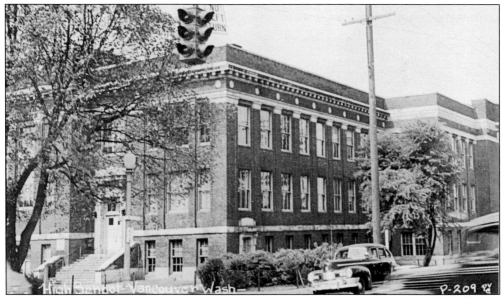

Vancouver High School opened in 1913 at the corner of Main and Twenty-sixth Streets. The handsome brick building saw graduating students for the next six decades. In 1955, the school was split into two student bodies, Hudson's Bay and Fort Vancouver High Schools. The decision to raze the old school created a storm of controversy that raged for years. Finally, the wrecking ball brought the last of the school down. The Vancouver Housing Authority, which now stands on the site, incorporated architectural elements from the school into its building.

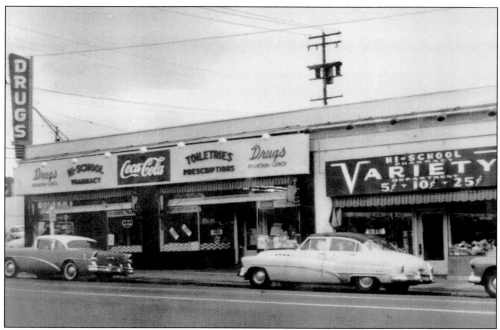

HiSchool Drug Store, with a popular soda fountain, stood across the street from the high school, hence its name. When the school was abandoned, it was considered inevitable that the pharmacy would also close. Young pharmacist Steve Oliva, starting his career, bought the business and developed HiSchool Drug into the largest family-owned chain in the state before eventually selling to Walgreens. (Oliva family collection.)

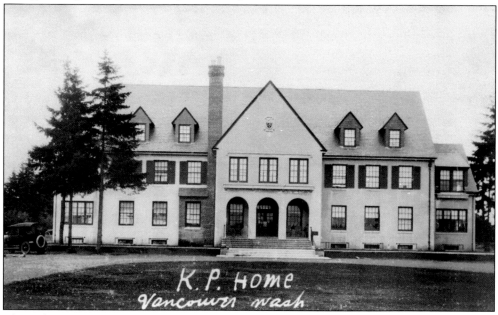

The Pythian Home, a forerunner of today's senior retirement centers, was opened in 1924 by the Knights of Pythias. A grand parade had accompanied the ground breaking in 1924. The Knights of Pythias is a fraternal organization founded in 1864. The building has been extensively altered and expanded, but the original can still be discerned. (Michael Jaffe collection.)

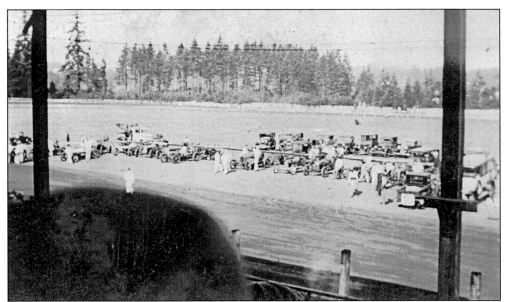

The racetrack on upper Main Street was well out of the city limits. Shumway Junior High School would be built on the site, but in its heyday, it stretched across most of what is today's Shumway neighborhood and would have reached to the freeway. It closed and was sold to a developer in 1907.

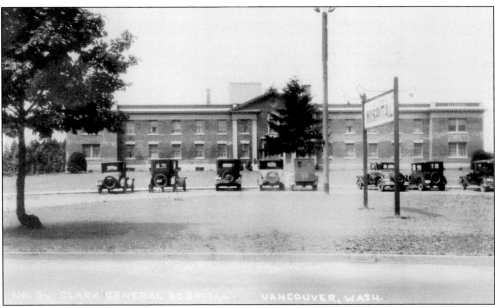

Clark County Hospital, now known as Memorial Campus of Peace Health Hospital, still stands at Thirty-third and Main Streets, but is unrecognizable in this image. It is buried under new facades and additions. The lawn has surrendered to a parking lot. The sturdy brick building was opened on September 7, 1929, at a total cost of $125,000.

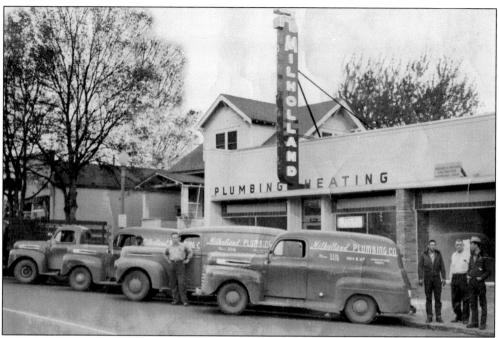

Milholland Plumbing's neon sign has a faucet on top and neon rings showing dripping water. This was a new store in late 1949. It moved from West Thirteenth Street. Jack Milholland stands on the sidewalk with his son, Walt, to his right and John Errington to his left. Dick Diment stands in front of the second truck and just visible over the hood is Jim Overall. Today, the American Cancer Society's Discovery Shop occupies the space at 2011 Main Street.

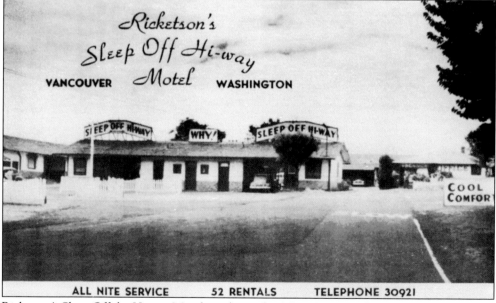

Ricketson's Sleep Off the Hi-way Motel was located at Main Street and Forty-first Street. There was a Jet Gas Service station on Main Street, and the driveway to the motel curved next to it to be off the highway. The Washington Department of Transportation building has taken the place of both businesses.

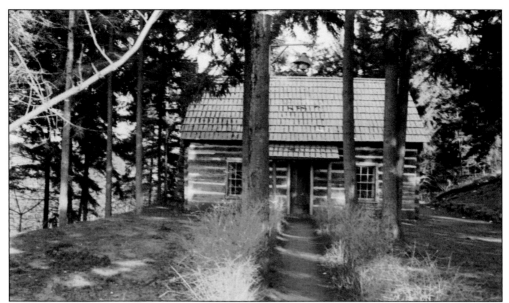

Covington House was moved to Main Street in Vancouver in 1926 by the Fort Vancouver Restoration and Historical Society. This image from 1933 shows the little house hidden by huge trees. The wooded parkland behind it will be swallowed up by the interstate highway in years to come. (Library of Congress.)

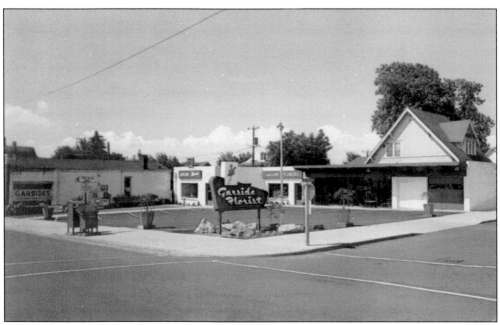

Garside Florists stood at Twenty-first and Main Streets for many years. Eventually, the owners would close this shop and reopen on the Heights on Mill Plain Road, where they continue to do business.

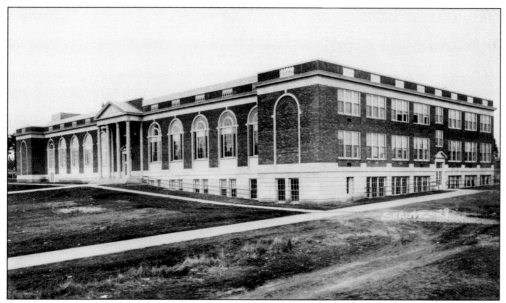

Once known as Shumway Middle School, this building now houses the Vancouver School of Arts and Academics. The familiar entrance to the school is now on the opposite side of this view. The facade now carries glowing tile murals in the bricked-over arches of the windows.

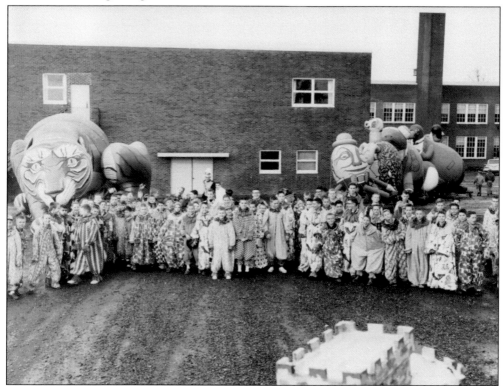

The students at Shumway Middle School take part in a grand giant balloon extravaganza that progressed to and from the school. It is hard to imagine today's middle school boys donning the clown costumes as readily as did these 1964 students. (Greater Vancouver Chamber of Commerce.)

Seven

WATERFRONT

Vancouver is truly a river city. The Hudson's Bay Company chose this location to take advantage of the transportation opportunities that the river offered. Settlers often arrived via the water. The river offered power for gristmills and lumber mills. The port brought commerce and employment. Fishing offered both sustenance and sport. It also, unfortunately, for many years was a receptacle for disposal of undesirable substances. The river was also a barrier. The railroad did not reach Vancouver and roads stopped at the river. Only a ferryboat connected the city with points south of it. In 1908, the railroad bridge was finished into downtown Vancouver. Today, railroad tracks hug the riverfront, creating a barrier of their own. On Valentine's Day of 1918, the Interstate Bridge opened. That day, over 4,000 people crossed the bridge, more than half by streetcar. Nearly 500 cars and trucks crossed, but only 78 horse-drawn vehicles. There were also 15 head of livestock. Tolls collected amounted to $287.75 to repay the county loan that built Vancouver's share. The city grew and a second span rose next to the first. The Glen Jackson Bridge joined I-205. Thousands and thousands of vehicles stream across those bridges every day. The stern-wheelers that plied the river are gone, and pleasure boats dot the water on weekends.

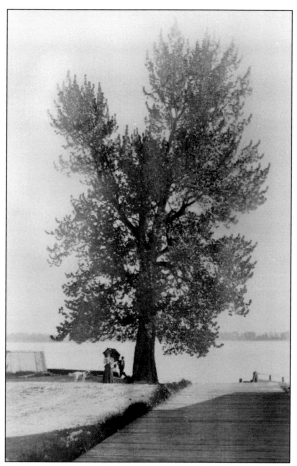

The Witness Tree was the beginning point for all property lines in pioneer Vancouver. It marked the Williamson and Amos Short claims, and it marked the Army claims as well as the City of Vancouver claims. Many initials were carved into the bark of the balm of Gilead tree on the edge of the river.

The Witness Tree washed away in 1912. In this image, men explore the downed giant. Cuttings from the tree were planted around the city, but none survive. In 1989, the State Surveyors Association back surveyed and found the marker for the tree again, in the parking lot for the riverfront restaurants.

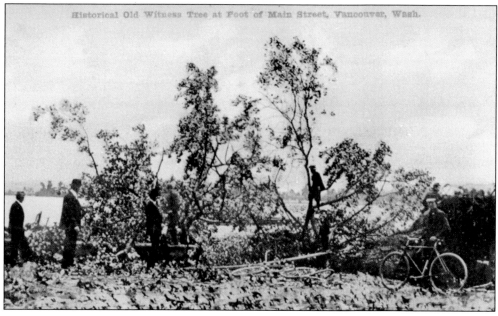

Historical Old Witness Tree at Foot of Main Street, Vancouver, Wash.

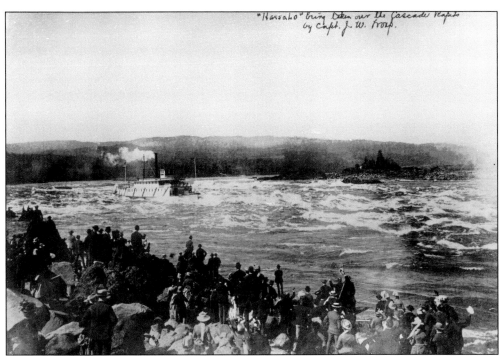

They don't make city councilmen the way they used to! In this image, Capt. James Turnbull, a Vancouver councilman, is taking the riverboat *Hassalo* through the Cascades, thereby proving that the Columbia River was navigable from the sea to the Snake River. He had done it once by accident and when he announced he would do it again, 200 people journeyed up the river to view the daredevil feat. (Library of Congress.)

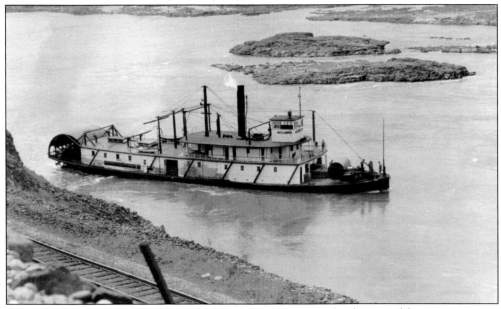

Stern-wheelers have practically vanished from the river except for those used for entertainment. The swift, shallow-draw craft such as the *Umatilla*, shown in this 1933 image, could navigate the Columbia's strong current and nose into the mud for a landing.

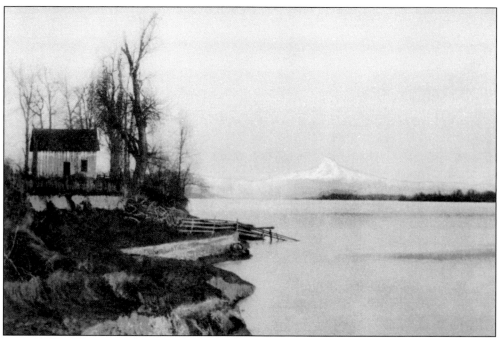

A postcard mailed in 1912 depicts a bucolic waterfront with Mount Hood on the horizon. This is probably from the area of Waterfront Park. The artist's name is worked into the bluff below the little structure, but unfortunately is not legible.

A ferryboat makes its way across a serene Columbia River against a backdrop of a heavily forested Hayden Island. There are no bridges as yet, no shopping center, and no Portland buildings rising on the hills in the distance. (Library of Congress.)

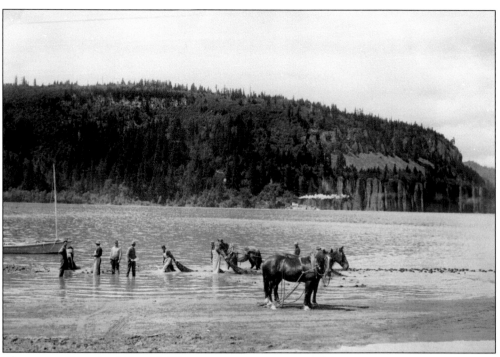

The nets used on the Columbia River were so heavy with fish that even a gang of men could not bring them in. This crew from Vancouver is using horses to haul the nets ashore.

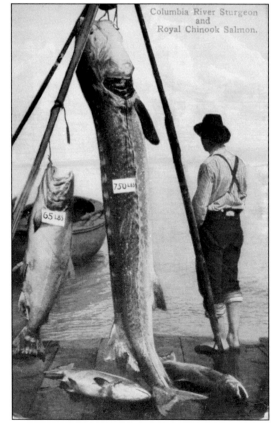

Columbia River Sturgeon and Royal Chinook Salmon.

Sturgeons grow very slowly, so this specimen, from around 1912, is a very old fish. The label puts its weight at 750 pounds. The chinook salmon next to it is estimated at 65 pounds. Other fish, that today would be prize catches, lie on the ground.

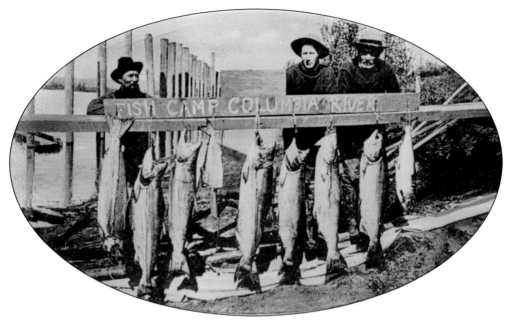

These fishermen from a Vancouver fish camp have enjoyed a good day's fishing and have enough salmon for a few feasts. Great runs of salmon supplied not only the sportsmen, but the commercial canneries as well.

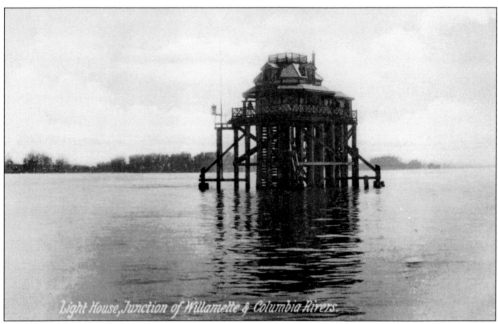

The lighthouse at the confluence of the Columbia and Willamette Rivers was operational from 1895 until 1935. It was an octagonal two-story structure perched atop pilings. The lighthouse keeper maintained a lantern with a white light flashing every four seconds and a fog bell every ten seconds. The light was electrified and the house moved to Kelley Point. It burned down in the 1950s.

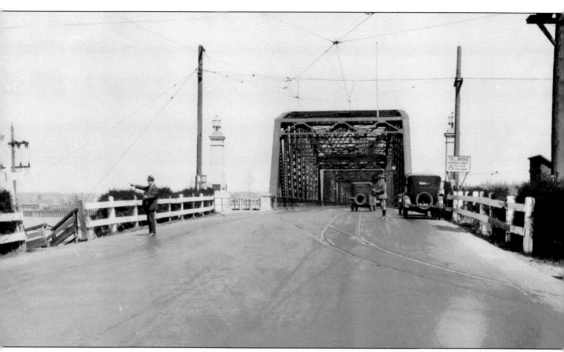

Two men inspect damage to the fence on the Interstate Bridge while a third stands by the parked car by the curb. This is today's northbound span. Streetcar tracks enter from the right. The speed limit is 15 miles per hour. (Washington State Archives.)

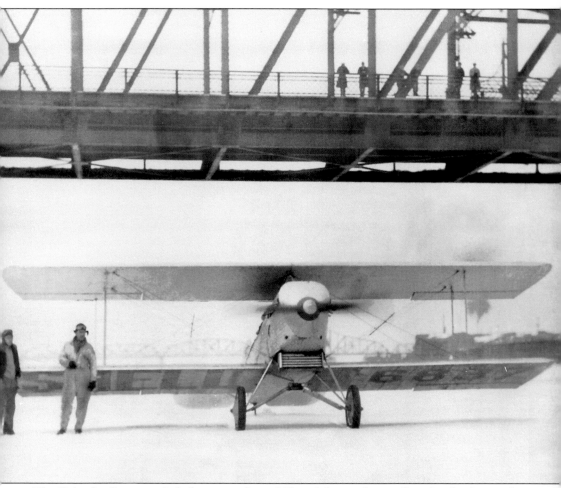

The Columbia River regularly froze over. It would be solid enough to walk to Portland, or as this image shows, to use as a landing strip. The pilot did not stay long on the river, but it was long enough to attract the spectators on the bridge above. The National Weather Service credits the many dams on the river with preventing a solid freeze of the waterway today. (*Columbian* newspaper.)

In 1942, the Kaiser Shipyards seemed to appear almost overnight at the Hidden Farm on the north bank of the river. The city population expanded with new residents as workers poured in to fill new jobs. The yard was completed in just four months, but even before its completion ships were moving off the ways. In this nighttime image, great whirly cranes march down the tracks through the 24-hour bustle.

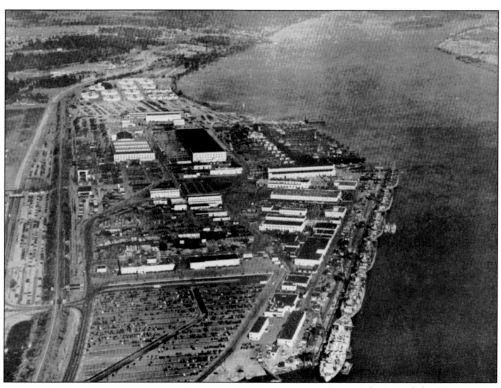

An aerial view of the Kaiser Shipyards shows its size. Six ships are moored at the outfitting docks; the ways are just above them in the photograph. The North Bank Railroad Line runs at the far left of this image. The farthest buildings in the complex are on the present-day site of Marine Park and the Water Reclamation Center.

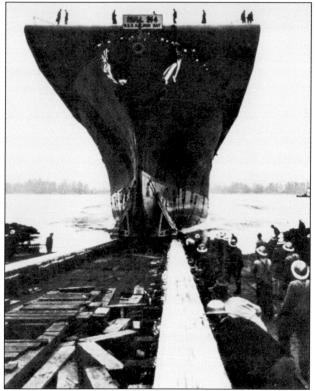

On October 15, 1943, the USS *Kalinin Bay* slid down the ways into the Columbia River. Every launch was an occasion for celebration. Flags, music, smashing a bottle against the prow, and cheering always marked the event. Vancouver was intensely proud of the ships that it built and followed their courses through the war.

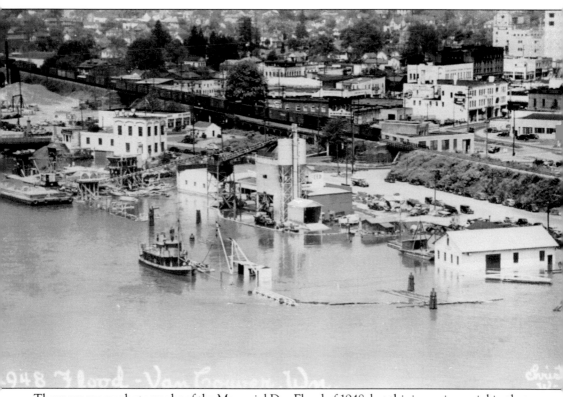

There are many photographs of the Memorial Day Flood of 1948, but this image is special in that it shows the relationship between the town and the river. In the lower right, the Coast Guard station is almost underwater, while the fireboat *Bluebell* rides at anchor. A grain barge is moored next to a wrecked dock, and a freight train is just clearing the Washington Street Bridge. The brewery dominates the skyline of the city. The Coast Guard and the loading dock have long since disappeared.

January 1951 brought record-shattering cold to the Pacific Northwest. On the last day of the month, Vancouver recorded 4 degrees below zero. The Columbia River did not freeze over, but great chunks of floating ice made it all but impassable. In this photograph, a steel-hulled tug breaks the channel open at the railroad bridge.

Eight

PORT OF VANCOUVER

Esther Short left the waterfront portion of her land claim to the City of Vancouver to be a "public wharf forever."

When Clark County citizens voted in 1912 to form a port district, they could not imagine the changes that would be brought to the community. The wharf was used for shipments of lumber and fruit, predominately prunes. The lumber was formed and chained into rafts. Those rafts could be floated down the river to the sea.

World War I changed the port as much as the town. The Standifer Shipyard sprang up almost overnight on the riverfront. Thousands of people poured into Vancouver, and women went to work in the shipyards for the first time. The Standifer Company constructed substantial buildings, thinking that the war would last for a very long time. When the war ended, the contracts ended. Civilian shipbuilding could not keep the company afloat, as it were. Eventually, the port would acquire the land. That attracted businesses to the port, laying the groundwork for the economic engine that is seen today.

Federal matching funds built Terminal Two in 1936. Bonneville Dam, opened in 1937, brought cheap electricity. That brought Alcoa to Vancouver. Grain elevators rose on the riverbank.

Today, with three elected port commissioners, the port creates infrastructure for industries to locate there. The 75 port districts in the state of Washington are formed by election to develop industry, trade, commerce, and employment for each particular district. They, unlike other local governments, may buy and sell land for profit. The port handles exports of scrap metal, wheat, and minerals, with imports of wind energy components and automobiles. Vancouverites have become used to seeing the trucks carrying huge wind power towers creeping from the port to I-5.

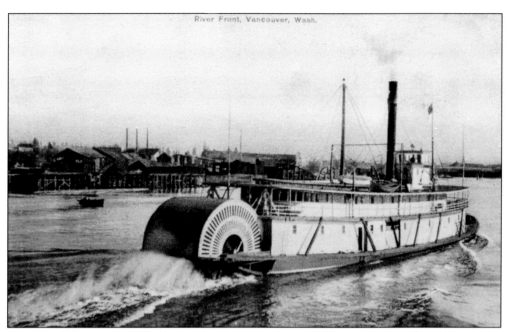

A postcard shows a stern-wheeler making its way upriver past Vancouver. Wooden pilings of the lumber docks line the riverfront. There are as yet no bridges across the river. There were few roads. For faster travel, the river was the highway.

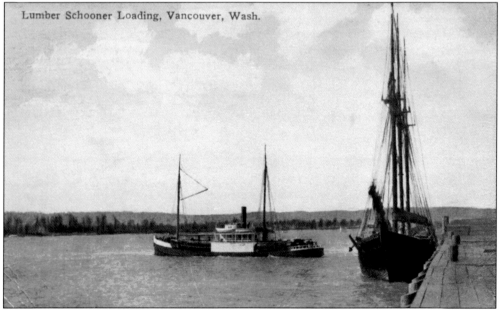

Lumber Schooner Loading, Vancouver, Wash.

"Lumber Schooner Loading, Vancouver, Wash." is the title on this postcard. It was mailed in April 1912, the year that the citizens voted a port commission into being. Lumber and timber were the staples of the port for many years. The port was still referred to as a "lumber wharf" at this time.

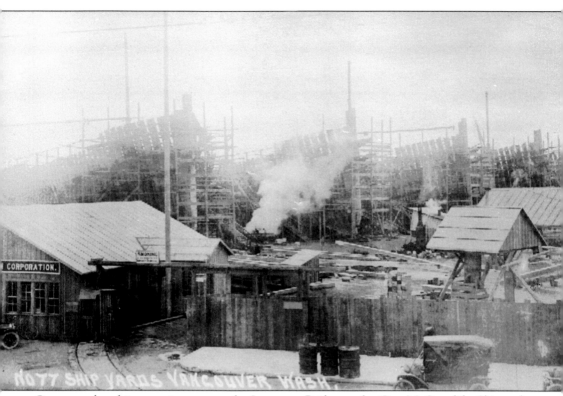

Great wooden shipways rise next to the Interstate Bridge as the Guy M. Standifer Shipyards swing into the task of building warships for the World War I effort. For the first time, women went to work in the shipyards. Decent women could not go into a restaurant alone, so lunchtime was difficult for the recently hired female shipbuilders. The YWCA made its first appearance in Vancouver by opening a sandwich stand for women only.

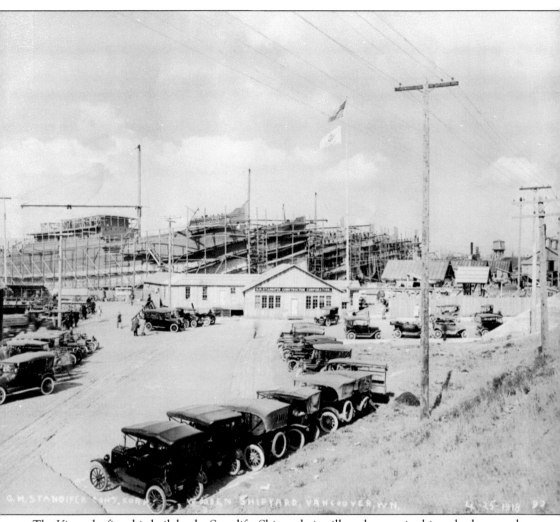

The *Kineo*, the first ship built by the Standifer Shipyards, is still on the ways in this early photograph. It would only sail until 1924, when it was scrapped. As of this photograph, it was necessary to provide parking lots for employees, as is evidenced by the collection of vehicles tidily lined up at the entrance. The Guy M. Standifer Company was in the construction business in Oregon before the war, building houses.

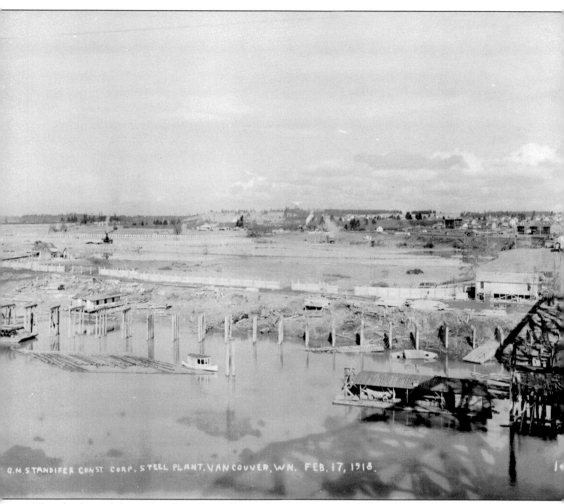

G.N.STANDIFER CONST CORP. STEEL PLANT, VANCOUVER, WN. FEB. 17, 1918.

The shadow of the railroad bridge falls on the right side of this image of the Standifer Steel Shipyard under construction in February 1918. This would be a second shipyard, a companion to the wooden ships underway by the Interstate Bridge. The Great War would end nine months later, making all of this obsolete. The Liberty Hotel, later apartments, was built to house the workers from the yards, but the war ended before they were used. (Port of Vancouver.)

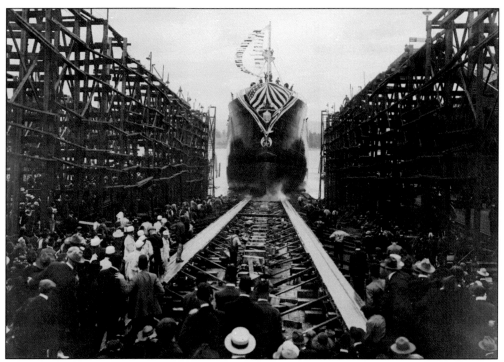

During the Shrine convention of June 1920, the wife of the imperial potentate of North America, Ella Garretson, sponsored the launch of the *Antinous*. A cargo ship, the *Antinous* would serve until September 23, 1942, when it was torpedoed and sunk.

The Mackall-Paine Wood Veneer plant took over a brick building left by the Standifer Shipyards. It was a successful business for many years. Lumber was plentiful, and the logs could be floated to the port. The main problem was the tidal nature of the river: Sometimes the river could drop 15–20 feet. The company had to install special cranes to bring the logs up. The plant was sold to the employees in 1955, becoming a co-op factory. The factory closed in 1996.

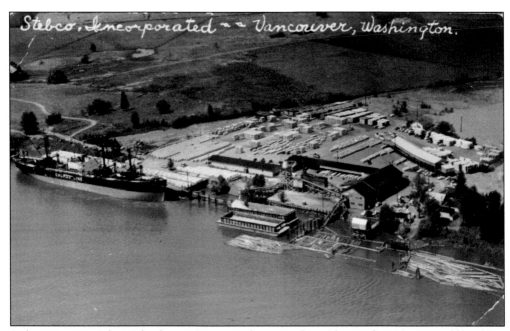

Stebco, Incorporated -- Vancouver, Washington.

Stebco Incorporated was a lumber operation just downriver from Alcoa in the 1950s. It would buy huge lots of timber and then form them into "cigar rafts," so called because of their shape, before floating them down the river to the Vancouver operation, where the logs could be turned into lumber.

The great logs from the forests of the Northwest were formed into huge cigar rafts held together by chains. They could reach several hundred feet in length and were capable of being towed at sea. They floated down the Columbia River to the lumber, plywood, and paper mills.

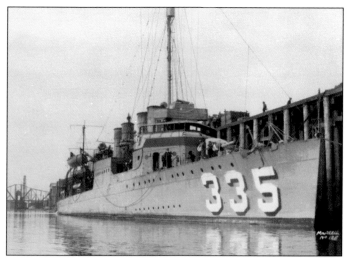

The 314-foot-long USS *Melvin* docked in Vancouver; it was a visitor at the Prune Festival in 1921. The *Melvin* was a peacetime ship. Its main patrol was the West Coast, with very few voyages outside of that area. It was a brand-new vessel at the time of this visit, having only been commissioned a few weeks. It was struck from the Navy's list on May 8, 1930, and scrapped at Mare Island in San Francisco.

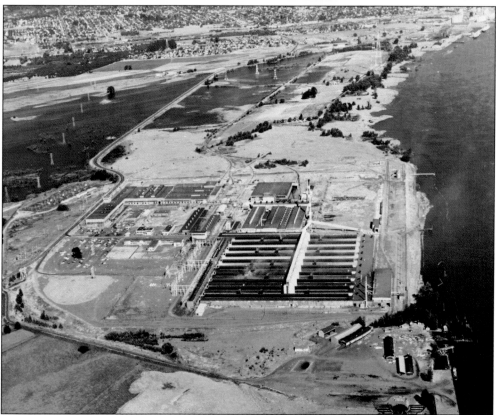

Alcoa was drawn to Vancouver by the cheap electricity brought by Bonneville Dam. It opened on 300 acres in the port in 1940. Within two years, the United States entered World War II. The plant ran 24 hours a day. Electric prices inched upward and demand lowered. In 1985, Alcoa sold to Vanalco, which would become Evergreen Aluminum. Neither company was as successful as Alcoa had been. Contamination of the ground around the plant added to Evergreen's woes, and it finally closed for good. In 2008, the port bought the plant, cleared the site, and cleaned up the pollution. It is now Terminal 5.

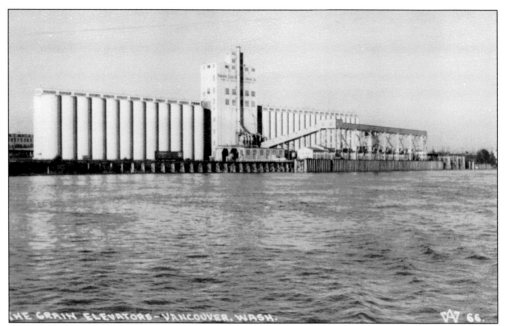

Completion of the grain elevator by the Pacific Continental Grain Company in 1934 was a major step forward for the Port of Vancouver. The prospect of international grain transport emphasized the need for deepening the channel to 32 feet.

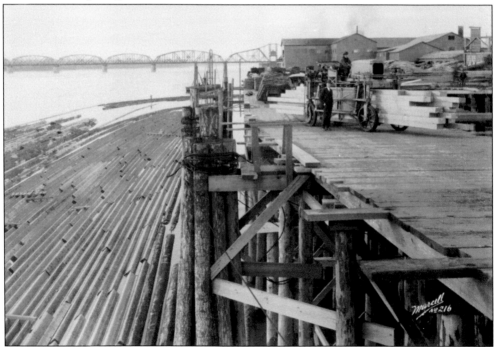

The Columbia River Paper Mill opened at the port in 1928. In 1962, it became the Boise Cascade Company. The plant made security paper for checks and similar uses. In 2006, the company offered the site for sale. A group of Vancouver businessmen bought the property and cleared it for development

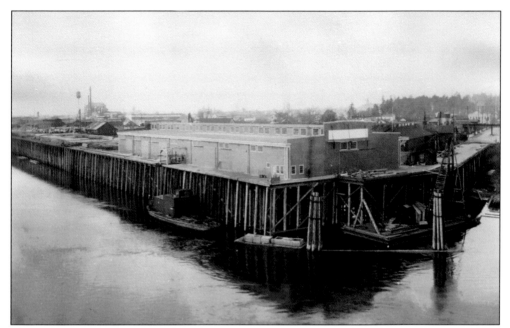

The city prune warehouse stands at the gateway to Vancouver in this 1930s image. Prunes were beginning to fade as the main crop in Clark County. Called the "Prune Capital of the World" and the "Italy of America," the community boasted of its abundant orchards. By the 1940s, however, the prune warehouse stood empty as canneries processed fruits more rapidly.

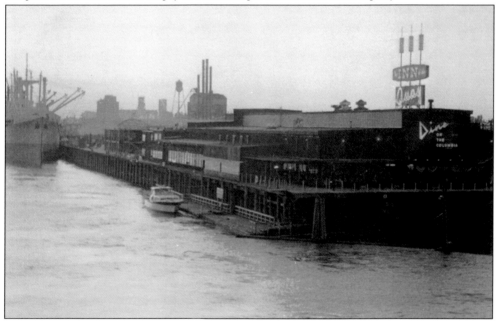

George Goodrich, owner of the Totem Pole Restaurant in Hazel Dell, had an idea. Vancouver needed a waterfront restaurant. He looked at the prune warehouse, a perfect location with a view of the river and the bridge. To convert the warehouse to a fine-dining restaurant would take $150,000. George said, "I didn't have $150,000, but I had 10 friends who had $15,000 each." The restaurant opened in 1960.

Nine

NEIGHBORHOODS

There are many who say that the oldest neighborhoods in the Pacific Northwest are in Vancouver. They will cite Officer's Row or the village outside Fort Vancouver. It is true that both of those locations were active neighborhoods in their day, and similarly, later neighborhoods grew near employment and services. Neighbors were close, enabling people to work on problems together and to warn each other of those problems or dangers.

Later, the automobile enabled people to live farther from their work and suburban neighborhoods developed. In Vancouver, the streetcar system from 1910 to 1926 grew neighborhoods along the line. Highways and freeways caused satellite neighborhoods to spring up.

World War II caused the most significant change in neighborhood growth. The Kaiser Shipyards and Alcoa brought thousands of workers to the city. Six wartime housing developments sprang into being almost overnight. While most of those houses were dismantled after the war, the more sturdily built still remain, notably on Harney Heights and in Fruit Valley. While the temporary houses may be gone, the names of those developments remain as names of neighborhoods, including Bagley Downs, Ogden Meadows, and Fruit Valley.

Neighborhoods are not just houses. They are their own schools and churches. Those often disappear as the city grows, becoming too crowded or obsolete. When that part of a neighborhood vanishes, that is often the most keenly missed. Neighborhoods are also the local businesses, the local grocery stores, filling stations, and beauty salons. Today, technology has brought a new dimension to the neighborhoods, allowing a quick exchange of ideas and notifications of problems or celebrations.

Vancouver chose to emphasize neighborhoods by forming neighborhood associations, often in response to a problem. In the 1990s, the city government decided to recognize those neighborhood associations by forming a city department of neighborhoods. Today, there are 66 recognized neighborhood associations, each with its own identity.

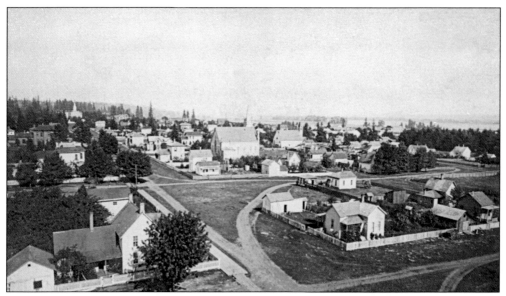

Vancouver in 1885 was a small community of tidy frame houses, barns, and chicken coops. The Academy can be seen in the distance in the middle right, and the First Presbyterian Church is in the center. (First Presbyterian Church collection.)

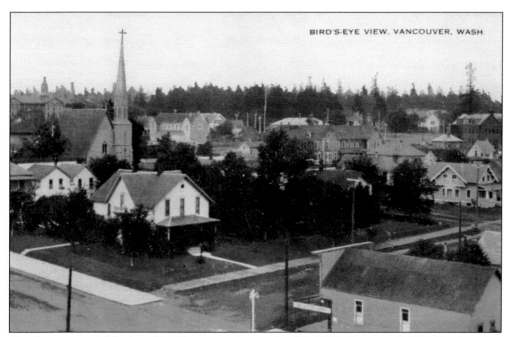

Another cozy neighborhood in Vancouver is seen in this 1919 photograph. The Presbyterian church again is the landmark, with the tower of the Academy barely visible on the horizon. The Salvation Army hut is in the lower right corner.

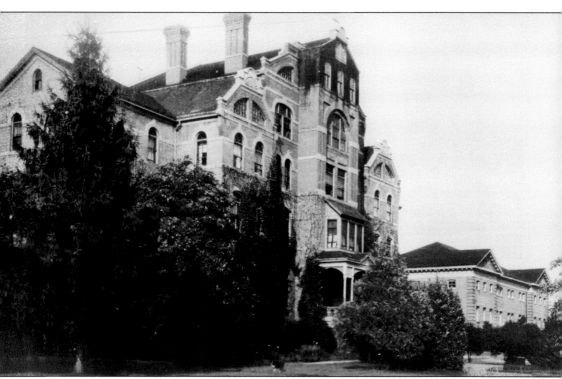

The Washington School for Defective Youth was established in 1886 by the territorial government. Today, readers might cringe at that name, but it was the politically correct term for that era. The students included blind, deaf, developmentally disabled, and those with any number of physical impairments. By 1889, the legislature decreed that parents of all defective youth must send them to this school or be guilty of a misdemeanor. It was built on the site of today's School for the Deaf. The school was subsequently divided into the State School for the Deaf and State School for the Blind.

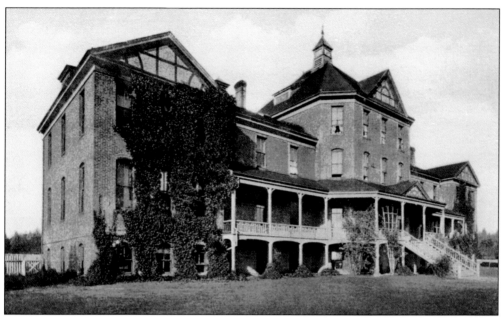

The first building on today's campus of the School for the Blind was built in 1892. It was to house the developmentally disabled children. They were transferred to Medicine Lake, and this building was demolished in 1916.

The administration building of the State School for the Blind was built in 1916. This image is of the structure in 1926. The surrounding buildings have been removed and the surviving edifice was extensively retrofitted for seismic stability.

Arnada School, at Twenty-fifth and H Streets, was the first brick school built in Vancouver. The Arnada Neighborhood derives its name from three friends of the developer: "AR" from Margaret Ranns, "NA" from Anna Eastham, and "DA" from Ida Elwell. The land was sold to the City of Vancouver in 1967, and Arnada Park now occupies the site.

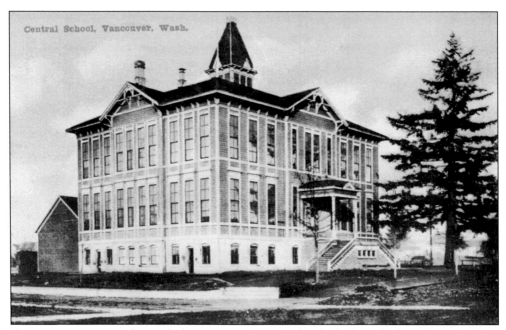

Vancouver was immensely proud of its imposing Central School, which was built in 1882 at Franklin and Thirteenth Streets. For many years, it was the only public school in Vancouver. A bell and bell tower were added in 1909, but were later found to be too heavy for the structure and removed. The building was demolished in 1940 to make way for the present-day county courthouse.

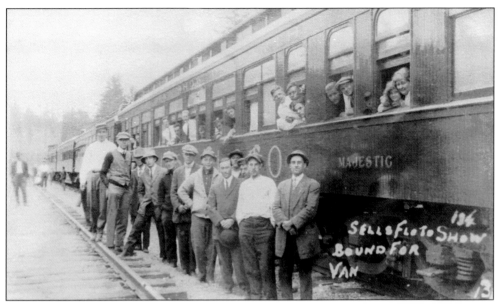

The Sells-Floto Circus would arrive in Vancouver in a 13-car train with a cast of hundreds. The train would be sidetracked for the two days the circus was in town. The performers slept in the railcars. Advance men would move through the city to drum up excitement.

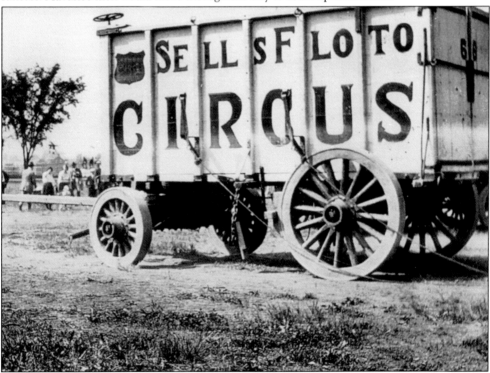

The Vancouver Circus Ground was between Kauffman Avenue and Harney Street, and between Nineteenth and Twenty-second Streets. The Sells-Floto Circus set up there, with elephants and horses and clowns. Unfortunately, in 1921, three bandits held up the circus treasurer and took over $25,000. The circus did not return.

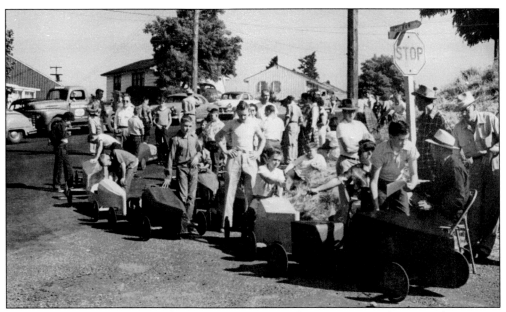

The soap box derby was a popular event in Vancouver for many years. It began in the wartime houses clustered around Harney Hill, with the cars careening down Grand Avenue. In this photograph, contestants gather, preparing to test their cars and themselves on Avenue K. Today, it would be Thirteenth Street and Grand Avenue. Unfortunately, the rumble of homemade racers is no longer heard here. (Greater Vancouver Chamber of Commerce.)

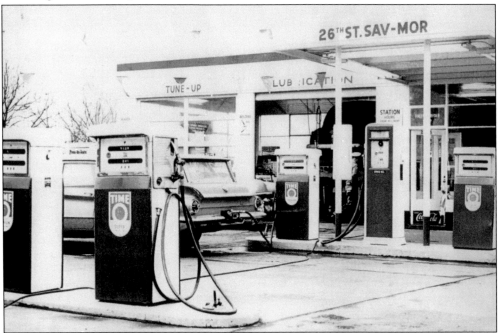

When service stations really were what the name implies, Freeman Ryder's Time gas station had stove oil and tires and did welding to boot. The attendant wears a snappy uniform and hat. The last sale of slightly over four gallons rings up a total of $1.09. There was a time when there were stations at almost every busy intersection. This one was at Fourth Plain Road and Kauffman Avenue.

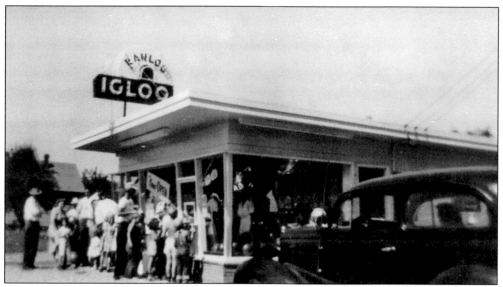

Strategically located between the State School for the Deaf and Harney School, what could be better than a hamburger stand? Ranlou Igloo opened on August 1, 1948. The restaurant has endured, although this view has not. (Igloo Restaurant collection.)

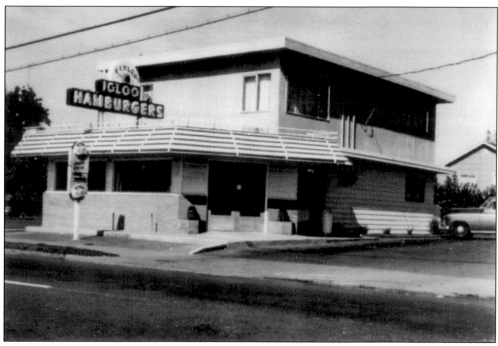

In 1954, the Igloo Restaurant completed the first of many major makeovers. A second floor was added and the front of the building was extended to permit seating. This is probably the view that most Vancouverites remember.

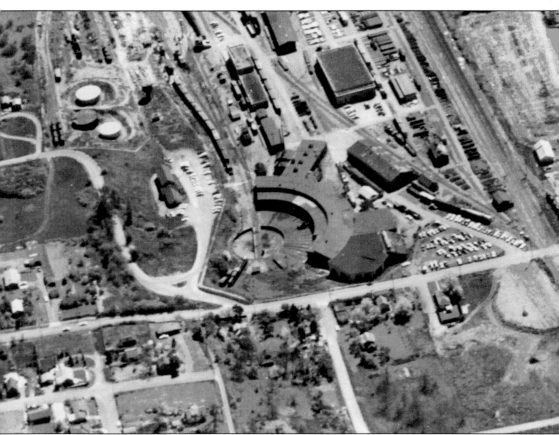

The Roundhouse once stood at Thirty-ninth Street and the railroad tracks; it could handle up to 18 locomotives. It was used, as the name implies, to turn locomotives around to head off in another direction. New developments in railroad technology lessened the need for these structures. After a 1971 fire, it was not rebuilt. (Port of Vancouver.)

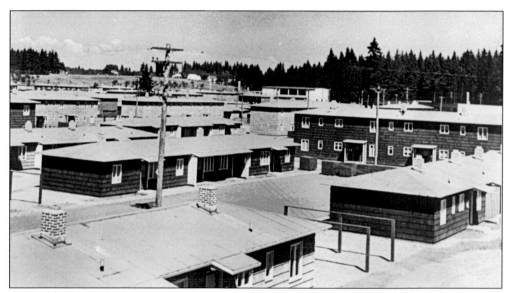

In World War II, the Vancouver Housing Authority was formed and tasked with building six of wartime "cities"—Fruit Valley Homes, Ogden Meadows, McLoughlin Heights, Fourth Plain Village, Burton Homes, and Bagley Downs. They were intended to house defense workers brought in to work in the shipyards. Although some neighborhoods remain, most were removed. This image is of the Bagley Downs Neighborhood. (*Columbian* newspaper.)

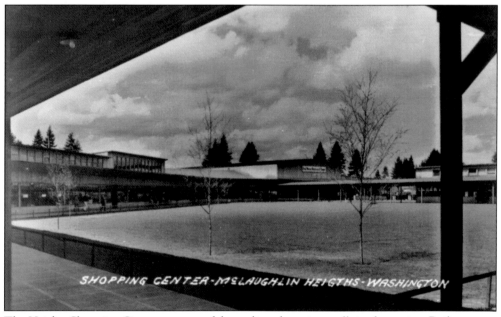

SHOPPING CENTER-McLAUGHLIN HEIGTHS-WASHINGTON

The Heights Shopping Center was one of the earliest shopping malls in the nation. Built to serve the wartime housing areas at MacArthur Boulevard and Devine Road, it was demolished after the war. A new shopping center was built just north, but it failed. It now houses some classes for Clark College and offices for other government agencies. (Michael Jaffe collection.)

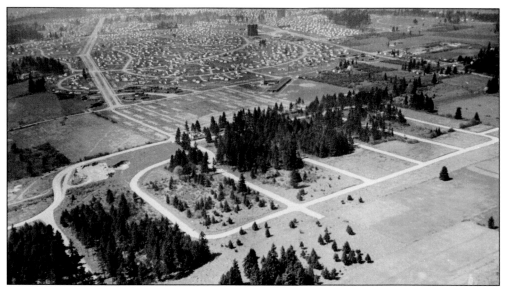

Postwar Council Crest Neighborhood has just been laid out in 1948. In the distance stretches McLoughlin Heights. The divided road on the left is MacArthur Boulevard. Mill Plain Road is to the right. Many of the wartime houses have been removed. Apartments still stand at the intersection of MacArthur Boulevard and Leiser Road. They will also be demolished as the wartime emergency housing makes way for permanent housing and commerce. (Clark County Genealogical.)

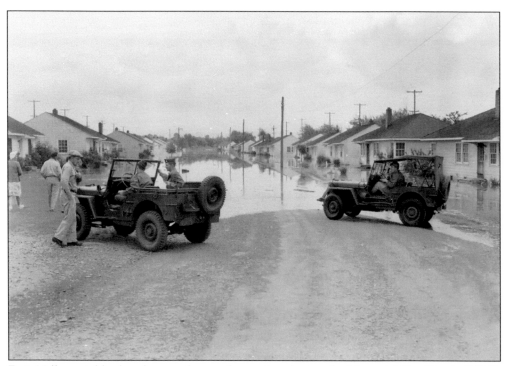

Fruit Valley neighborhood came close to destruction during the Memorial Day Flood of 1948. Many families were evacuated, but the neighborhood was spared, unlike Vanport across the river, which vanished forever.

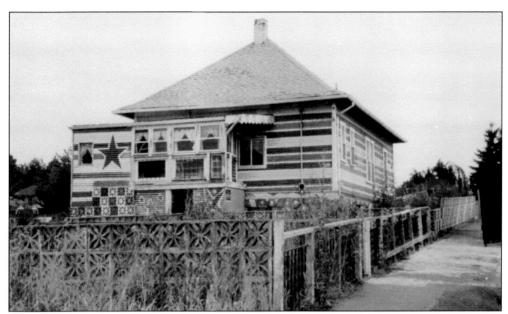

Claire and Lloyd "Ace" Parsons lived in a snug little house on Fifteenth Street. In 1972, Ace began to paint and decorate the house with a rainbow of colors, inside and out. A miniature Dodge City occupied the backyard. The Parsons welcomed visitors and what could have been an eyesore became a neighborhood treasure. The route of the Mill Plain extension was changed to preserve the house. Then Ace suffered a stroke and Claire passed away, leaving no one to care for the house. It was demolished in 1999. (Brian Loos collection.)

County Hospital at Fourth Plain Road and T Street has disappeared. During the polio epidemics of the 20th century, it housed isolation wards and an iron lung. The mentally ill were also treated at this location.

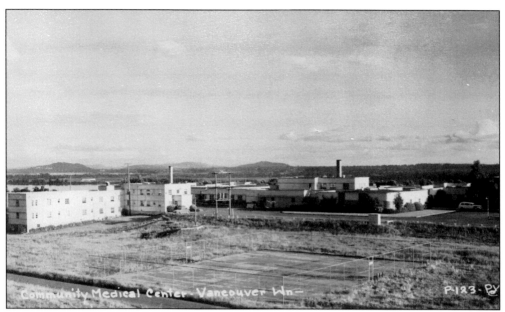

Kaiser Permanente Hospital was built during the war to serve the employees at the shipyards in both Vancouver and Portland. When the hospital was closed on June 1, 1942, it became Rose Vista Convalescent center at 5001 Columbia View Drive. That center itself closed, and the site was cleared.

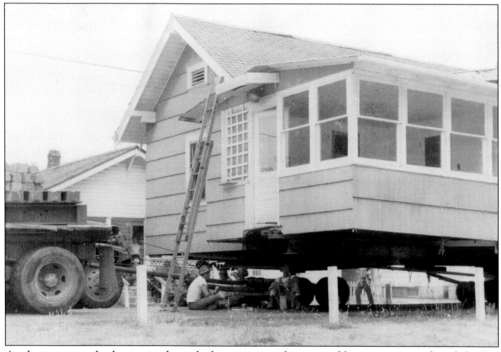

As the interstate highway cut through the city, many homes and businesses were demolished or moved. In this photograph, crews stop for lunch in the shade of one of the houses to be moved. (Washington State Archives.)

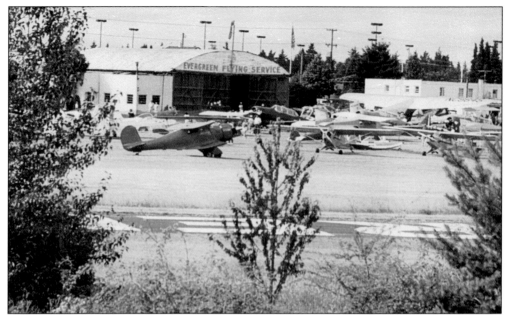

Roy C. Sugg, an attorney practicing in Vancouver, opened an airport on Mill Plain Road in 1944. Wally Olson bought it after World War II and operated Evergreen Flying Service–Suggs Field. Eventually the name Suggs disappeared and the field continued as Evergreen Airport. The Northwest Antique Airplane Club headquartered there and staged an annual event, the Fly-In. Olson died in July 1997, and his daughters found that they could not continue operating the airport. The property was sold, the airport closed, and the buildings were demolished. The facade of the Flying Service is in the Western Antique Aeroplane Museum in Hood River, Oregon. (Henry Spang Collection.)

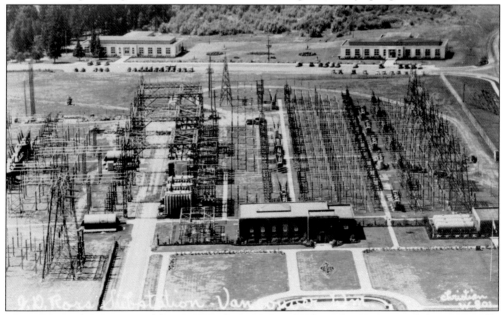

JD Ross Complex was named for James Delmage Ross, the first administrator of the Bonneville Power Administration. This small complex was the beginning of the huge installation that stands today at the north end of the city.

In 1949, Andresen Hill, south of MacArthur Boulevard, was a country lane. Two figures are seen in this image taking a stroll down a shady dirt road. It is strongly advised that no one attempt this today. (Washington State Archives, Clark County Public Works.)

This view of the Columbia River waterfront shows the foundations for the immense Glenn Jackson I-205 Bridge. The view of the broad Columbia River stretching across the expanse to Government Island would soon disappear forever. (Wenonah Bishoprick Purchase collection.)

DISCOVER THOUSANDS OF LOCAL HISTORY BOOKS
FEATURING MILLIONS OF VINTAGE IMAGES

Arcadia Publishing, the leading local history publisher in the United States, is committed to making history accessible and meaningful through publishing books that celebrate and preserve the heritage of America's people and places.

Find more books like this at
www.arcadiapublishing.com

Search for your hometown history, your old stomping grounds, and even your favorite sports team.